MW00614635

IMAGES
of America

OCCOQUAN

On the Cover: For more than 100 years after its founding early in the 19th century, Occoquan's mill complex was a center of town industry and commerce. Thomas Jefferson hoped to learn from its operation and George Washington sought its products. Here a riverboat docks alongside the main, or Merchants' Mill, a small part of which remains today and houses the Occoquan Historical Society's Mill House Museum. (Courtesy Occoquan Historical Society.)

21⁰⁰

IMAGES
of America

OCCOQUAN

Earnie Porta

ARCADIA
PUBLISHING

Copyright © 2010 by Earnie Porta
ISBN 978-0-7385-8664-9

Published by Arcadia Publishing
Charleston, South Carolina

Printed in the United States of America

Library of Congress Control Number: 2010926870

For all general information, please contact Arcadia Publishing:
Telephone 843-853-2070
Fax 843-853-0044
E-mail sales@arcadiapublishing.com
For customer service and orders:
Toll-Free 1-888-313-2665

Visit us on the Internet at www.arcadiapublishing.com

To Mom, Dad, Jackie, Eddie, and Barb

CONTENTS

ACKNOWLEDGMENTS

Space constraints make it impossible here to thank everyone who has contributed to this work, but there are some individuals who deserve special mention. First and foremost, this book could not have been compiled without the efforts of Martha Roberts, Dolores Elder, and June Randolph. Over the years, Martha has preserved for the Occoquan Historical Society (OHS) most of the photographs in this volume and—in addition to dealing with my persistent questions—has provided valuable assistance both through her intimate knowledge of the town and through the articles she has written for the OHS newsletter. Dolores Elder has also made invaluable contributions with her long-standing efforts to document the history of Occoquan for future generations. Her research skills are outstanding, and she patiently and promptly responded to every question I threw her way. Much of the written material in this text is informed by her work. June Randolph at one time or another has held virtually every official position in Occoquan; she was also a founding board member of OHS, and her recollections saved me precious time.

Others also helped in a variety of ways. Jeanne Bailey, Jess Brindisi, Bill Cooper, William Jennings, Rev. Charles A. Lundy, Cathy Bennett, and Marguerite Harris all provided wonderful photographs and helpful historical information. Claudia Cruise, Janet Quenzer, LaVerne Carson, Walter Bailey, Ken Brunsvold, Kristyn Gleason, Joy Zerby, Letty Lynn, and Don Lynn provided me with some relevant details or helped scan items. My friend Lorraine Musselman supported me in this as she has in every other endeavor. Michael Johnson and Charles Gailey of the Fairfax County Park Authority's Cultural Resource Management and Protection Section educated me on Occoquan's prehistory via another project. Naturally, I wish also to thank the University of Virginia for approving the reproduction of some images, and my acquisitions editor at Arcadia Publishing, Elizabeth Bray, for bringing this project to fruition. To the extent this work contains any errors, they remain mine alone.

Finally, I think it important to express my gratitude to both those who took, gathered, and retained the photographs contained herein, and to those current and former members of the Occoquan Historical Society (formerly Historic Occoquan, Inc.), who have labored selflessly to preserve the town's past. And of course, a special thanks goes to my wife Barb, whose patience is unsurpassed.

Unless otherwise noted, all images appear courtesy of the Occoquan Historical Society.

INTRODUCTION

*Yet no place can be more romantic than the view of Occoquan to a stranger, after crossing
the rustic bridge, which has been constructed by the inhabitants across the stream. He
contemplates the river urging its course along mountains that lose themselves among the
clouds; he beholds vessels taking on board flour under the foam of the mills, and others deeply
laden expanding their sails to the breeze; while every face wears contentment, every gale wafts
health, and echo from the rocks multiplies the voices of the waggoners calling to their teams.*

—*John Davis*

Thus in 1801 did the young English sailor-turned-novelist John Davis describe the settlement
near the falls of Virginia's Occoquan River. The community indeed seemed destined for a certain
prosperity, and Davis's description elicited the prediction from a friend that his "abode on the
banks of the river will make the stream classical in the annals of literary history."

The Occoquan River is a tributary of the Potomac, and thus part of the 64,000-square-mile
Chesapeake Bay watershed. A little more than 26 miles in length, it begins roughly in the center
of Prince William County, Virginia, at the confluence of Cedar Run and Broad Run, near what is
today the Brentsville Historic Area. On its way to the Potomac the Occoquan drops some 150 feet,
with more than half of this drop once occurring over a short series of falls just west of the town
that also bears the name. At first traveling in a northeasterly direction, the Occoquan follows a
serpentine path that includes almost a dozen sizeable oxbows before it meets its main tributary,
Bull Run, about 12 miles into its journey. Here the river begins service as the boundary between
Prince William County on the south bank and Fairfax County on the north. Several additional
large oxbows occur as the river turns toward the southeast. After 21 miles, it straightens and makes
its final run into Belmont and Occoquan Bays, ultimately emptying into the Potomac River.

Along the river's course the scouring effects of the Occoquan's waters have provided clues
to the area's geological past. Just 2 miles west of the river's mouth, large vertical shelves of hard
rock rise above the northern bank, dating from more than 200 million years ago when Virginia
and northwest Africa collided and the supercontinent of Pangaea formed. The fall line, marked
by narrow, walled valleys with rapids and waterfalls, reflects a more recent epoch. Some 20,000
years ago, the weight of the ice to the north caused a corresponding bulge in the local section of
the geologic plate. As elevation increased with the bulge, so too did the speed of the rainwater
and glacial melt, which rushed over the harder igneous and metamorphic rock, carrying sediment
and depositing it in the coastal plain that makes up today's Tidewater.

Humans have lived near the Occoquan River for at least 13,000 years. In fact, there are more
than 200 documented pre-European sites along the river's banks from its mouth to its confluence
with Bull Run. Jamestown's Capt. John Smith was the first European known to have visited the
area, doing so in 1608 during his exploration of the Chesapeake Bay. At the river's mouth he

encountered a town of the Tauxenent Indians, who later became known to the Europeans as the Dogue. Along their voyage to this point, Smith's party had encountered hostility from Native American communities affiliated with the paramount chief Powhatan, but the inhabitants at the mouth of the Occoquan treated Smith and his men well. It is from the language of the Dogue that both the river and the town take their name.

Decades passed before other Europeans followed Smith's voyage and settled the lands along the Occoquan. In 1651, a traveler on the Potomac spotted the cornfields of the Dogue (variously referred to in the sources as the Taux, Toags, Doags, Doegs, Dogue, and others) separated from the mainland by a swamp. "Doeg's Island" became a reference point for some of the land patents authorities granted in blocks of hundreds and thousands of acres along the Occoquan River during the 1650s, 1660s, and 1670s. After playing their part in the Susquehannock War and Bacon's Rebellion, the Dogue largely disappeared from history. Their lands remained, however, and were soon claimed by English colonists.

As the decade of the 1680s progressed, activity increased near the river's mouth. Col. George Mason patented vast lands on the western and southern shores of the Potomac adjacent to the Occoquan for tobacco cultivation. In 1684, the Virginia Assembly required that Mason operate a boat across the Occoquan to ferry the soldiers and horses of the militia. Several years later, European colonists were expanding northward from the lower Potomac in sufficient numbers for the Assembly to deem the fords on the Occoquan unsatisfactory. As a result, in 1691 the boat service at the river became a public ferry linking what was later to develop into Colchester and Woodbridge on the north and south banks, respectively.

Additional activity in the area followed on the heels of Robert "King" Carter. At the turn of the century, Carter participated in the latest round of speculation associated with the Occoquan watershed, obtaining in 1707 grants of 10 acres below the fall line and of more than 900 above it. Within the next 15 years, surveyors had laid out grants of land on all the low ground adjoining the Occoquan, Bull Run, Broad Run, and Cedar Run. Attracted by the apparent presence of copper farther north, Carter established a landing below the falls of the Occoquan and pushed a road north to the mines—today's Ox Road, Virginia Route 123. The mines were never to amount to much, but with the construction of the landings, Carter helped set the area on a path that was to dictate its future for the next century.

Regional tobacco production played no small role in determining this future. Virginia's Tobacco Inspection Act of 1730 required that tobacco be marketed only at public warehouses where it was subject to inspection and stored for sale. In 1734, authorities established one of these warehouses at the site of Carter's copper mine landing on the Occoquan; it was followed two years later by another warehouse. In the meantime, three years earlier, in 1731, the Virginia Assembly had created Prince William County, placing the county court, prison, pillory, and stocks on the north bank of the Occoquan River at the ferry landing. All this activity near the mouth of the Occoquan was substantial enough soon after this period that landowners petitioned the Virginia Assembly to lay out a town on its banks in both 1740 and 1742. Competing merchants to the south objected, but a compromise was reached that ultimately created the town of Colchester at the ferry landing on the north bank. At the same time the Virginia Assembly created another county, Fairfax, with its border marked by the Occoquan River and Bull Run.

Despite its dominance in the Virginia economy, tobacco was not always a stable commodity. For a 40 year period beginning in 1680, overproduction and conflict dramatically lowered its price. Early in this downturn Virginia officials recognized the need to diversify the colony's economy. There were several attempts to prohibit the production of tobacco and more aggressively regulate its sale. By the start of the 18th century, what the colonial government had unsuccessfully sought to mandate, the wealthier planters chose to do themselves, expanding into other sectors in recognition of the prolonged downturn in the tobacco markets.

Iron manufacturing was one of these sectors. Given iron's weight and the corresponding cost of transporting it, manufacturing iron was a local business in most of the world. But transportation by water from the Chesapeake was sufficiently inexpensive that the watershed's producers could

competitively export their iron to Great Britain. The iron business was also well suited for integration with tobacco cultivation, as iron provided suitable ballast for vessels that transported the light tobacco across the ocean.

As they approached the middle of the 18th century, entrepreneurs recognized the Occoquan as an attractive location for ironworks. In 1737, the Tayloe family, who already owned substantial tobacco and grain plantations farther south, opened an ironworks on Neabsco Creek, which flows into Occoquan Bay just to the south of the river's mouth. When tobacco prices began to fluctuate adversely yet again in the 1750s, John Tayloe II decided to expand beyond the Neabsco works. He financed a forge and contracted out the operation of a furnace on the Occoquan.

John Ballendine was a beneficiary of Tayloe family financing. In 1755, he bought out the warehouse property on the southern bank of the river, as well as some other local holdings, and constructed an iron furnace, a forge, gristmills, and sawmills near the falls of the Occoquan. Three years later he built his home, Rockledge, one of Occoquan's oldest structures, on a rock ledge above the river. Iron manufacture, however, required enormous amounts of charcoal for fuel, which in turn required large amounts of timber from the surrounding area. During the 1760s, in fact, Tayloe and his partner added more than 2,500 acres to the Occoquan Company holdings largely to meet their charcoal needs. It was not enough. By the early 1770s Tayloe apparently abandoned his sawmill along the Occoquan due to the scarcity of timber and its distance from the complex. When the American Revolution reached its conclusion, it was clear that the Occoquan ironworks were past their prime.

As this transformation took place, wheat farming had also sufficiently developed in the Virginia backcountry to encourage some business associates of Tayloe to move away from iron and devote their interest to the flourmills along the Occoquan. John Ballendine's operations eventually passed through several hands, until by the end of the 18th century, they belonged to the Quaker Nathaniel Ellicott. Taking advantage of the spread of wheat cultivation in the backcountry, Ellicott converted the Occoquan works to milling operations. His main mill may have been the first automated mill in the young United States of America.

Ellicott may justly be considered one of Occoquan's founding fathers. In addition to operating an advanced mill complex, he also built a bridge across the Occoquan in 1797, in direct competition with the bridge at Colchester less than 2 miles downriver. With two business partners, in 1804 he laid out the Town of Occoquan on 31 acres. Later, he constructed a road that north of Pohick Church branched off from the old north-south road. It thus bypassed Colchester and diverted much of the north-south traffic through the new town Ellicott had helped create.

Although the Ellicotts left Occoquan for Alexandria in 1816, another Quaker family, the Janneys, soon became prominent in the town. In addition to operating the mill complex for more than 100 years, members of the Janney family also built a cotton mill, or factory, just to the west of the main mill complex. This stood until the Civil War.

Occoquan was the site of several small engagements during that conflict, the most notable of which were two Confederate raids in December of 1862. Perhaps more telling, however, was an incident that happened just before the war. On July 4, 1860, supporters of Abraham Lincoln erected a pole flying pennants bearing the names of Lincoln and his running mate Hannibal Hamlin. Members of the Prince William Militia rode into town several weeks later and chopped the pole down. In the subsequent presidential election that November, Abraham Lincoln received 55 votes in Prince William County—all of them from Occoquan.

Since the days of iron foundries and grain mills, Occoquan has hosted a variety of industries and commercial enterprises tied to the river. Rock quarrying has always had the most economic staying power, with viable quarries still using the river for economical transport even today. Other businesses have also flourished. One of these, the lumber industry, at first took advantage of local timber resources; later the town became a transshipment point for wood from the interior. River ice enjoyed a boom starting in the late 19th century. At that time ice cut from the Occoquan traveled to Alexandria and Washington, D.C. Shipbuilding also prospered, with both the Hammill and Underwood families operating yards along the town's waterfront. Excursion boats once frequented

the area as well, seeking not only the amenities offered by the town, but also the pleasant wooded paths traced by the race from the mill complex. Ever since Nathaniel Ellicott built his first bridge across the river in 1797, subsequent businessmen had ensured that the town remained on the East Coast's main north-south route. At one time weary stagecoach travelers could refresh themselves in town at the Occoquan, Alton, or Hammill hotels.

During the 20th century, three events figured prominently in Occoquan's history. In 1916, a fire swept through town, destroying numerous structures so that most buildings in town today post-date that period. Later, in the 1950s, the Alexandria Water Company built the Occoquan High Dam, which today holds back a reservoir of some 8.3 billion gallons of water. Finally, in 1972, Hurricane Agnes struck. The resulting floodwaters wreaked havoc on the town's waterfront, sweeping away the iron Pratt truss bridge that had stood since 1878, and flooding most of the town's main avenue, Mill Street. It was a devastating blow to the town. Many traditional small businesses did not recover; they closed their doors, never to reopen.

As occurred after the 1916 fire, however, those who remained in Occoquan after Hurricane Agnes rebuilt. Though much of the town's past now remained but a memory, Occoquan moved forward, transforming itself into the intriguing mix of old and new that visitors experience today.

One

FROM THE EARLIEST BEGINNINGS TO THE CIVIL WAR

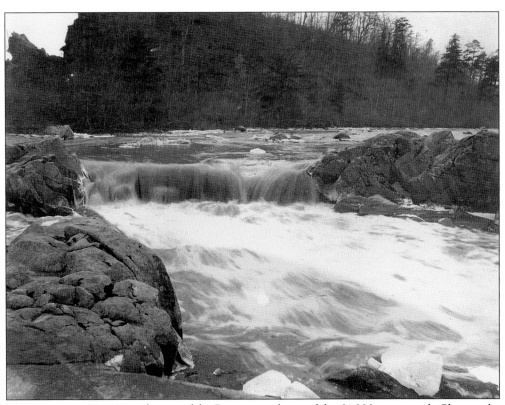

The Occoquan River is a tributary of the Potomac and part of the 64,000-square-mile Chesapeake Bay watershed. More than 26 miles long, it originates at the confluence of Cedar Run and Broad Run near the center of Prince William County. For roughly 12 miles it carves a northeasterly serpentine path. Then, at its intersection with Bull Run, it turns southeast toward the Potomac.

Along its course, the scouring effects of the Occoquan River have revealed clues to the region's geological past. Just a few miles west of the river's mouth, large shelves of hard rock rise above the banks, dating from more than 200 million years ago when Virginia and northwest Africa collided and the supercontinent of Pangaea formed. Though glaciers did not carve the Occoquan, they help create its watershed. During the Tioga period of the Wisconsin glaciations, the weight of ice far to the north caused a bulge in the geologic plate on which the Occoquan River now lies. As elevation increased with the bulge, so too did the speed of rainwater and glacial melt, which rushed over the harder igneous and metamorphic rock, carrying sediment and depositing it in the coastal plain that makes up today's Tidewater.

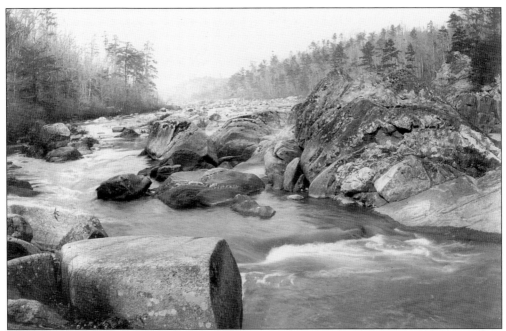

Like the broader Chesapeake Bay watershed, the Occoquan drainage area was once covered in deep forest when the expanding glaciers caused a drop in sea level and the ocean retreated beyond the continental shelf. Over the last 10,000 years, the reverse has occurred. Glacial melt has caused the sea level to rise, flooding not only the Chesapeake Bay but the valleys cut by tributaries like the Potomac and the Occoquan. The town of Occoquan sits just below the fall line, which is the farthest navigable point up the Occoquan River, where the Tidewater and the Piedmont regions meet. Above and below are areas of the river once known to some as the Upper Mullet Hole and the Taylor Hole, respectively.

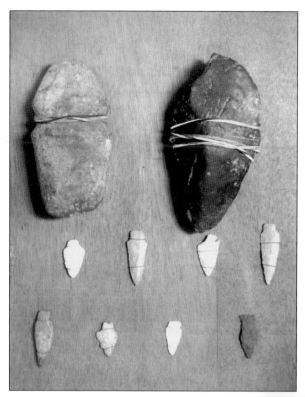

Humans have lived near the Occoquan since at least the Paleo-Indian period, some 13,000 years ago. From the mouth of the river to its confluence with Bull Run, a distance of approximately 14 miles, there are more than 200 documented pre-European sites along the river's banks. The earliest inhabitants likely traveled widely in bands. As the environment changed they eventually began to establish settlements along the banks and mouths of rivers. At left and below are axe heads, arrow points, and spear points found in the region and now housed at the Occoquan Historical Society's Mill House Museum.

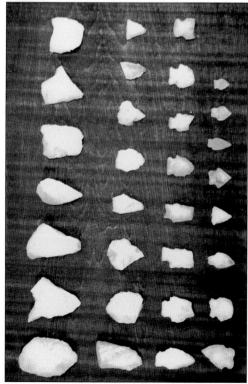

Capt. John Smith was the first European known to have visited the Occoquan area. Smith arrived during his exploration of the Chesapeake Bay in 1608. Somewhere near the river's mouth, likely on land now submerged by Belmont Bay, he encountered the Tauxenent Indians, who after the middle of the 17th century came to be known as the Dogue. Tradition holds that the name "Occoquan" comes from a Dogue Indian word meaning "at the end of the water." More recent linguistic analysis, however, suggests that it may instead have meant "a grove of trees." At right is the title page of Smith's *General Historie of Virginia*. Below is a reproduction of Smith's map of Virginia. The town of Tauxenent sits just to the lower left of the large "N" on the map. (Right courtesy of Images, Virtual Jamestown, Virginia Center for Digital History, University of Virginia [www.virtualjamestown.org/map10b.html]; below courtesy of Original Maps, Virtual Jamestown, Virginia Center for Digital History, University of Virginia [www.virtualjamestown.org/jsmap_large.html].)

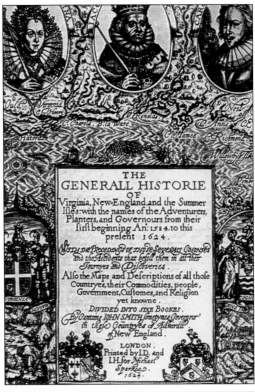

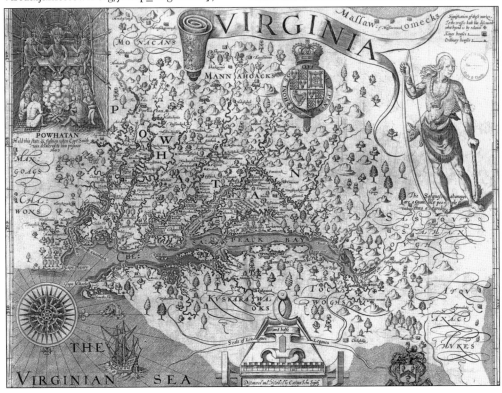

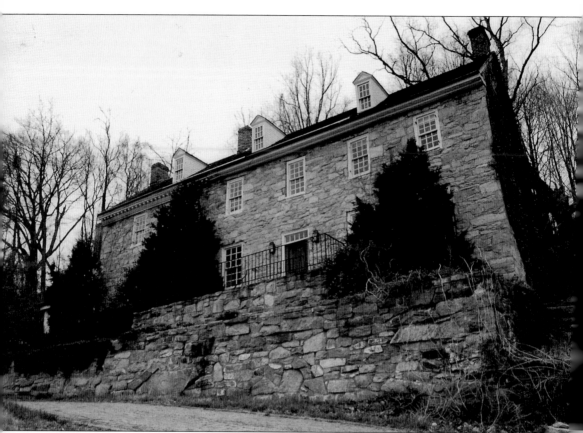

Although speculators and others patented lands along the Occoquan in the 1600s, the first evidence of more substantial European settlement dates from 1734, when the Virginia Assembly directed that a public tobacco warehouse be constructed on the river's north bank adjacent to a copper mine landing built earlier by the Carter family. Two years later Valentine Peyton established a warehouse on the south bank of the river. From these modest beginnings Occoquan eventually emerged. In 1755, John Ballendine, with the backing of the Tayloe family, purchased the Peyton and other properties. Upon these he constructed an iron furnace, a forge, gristmills, and sawmills, thus making iron manufacturing Occoquan's first major industry. Three years later, in 1758, Ballendine built his Occoquan home, Rockledge, pictured above. William Buckland, the indentured architect, joiner, and builder who worked for George Mason on Gunston Hall, also supplied plans and workmen for Rockledge.

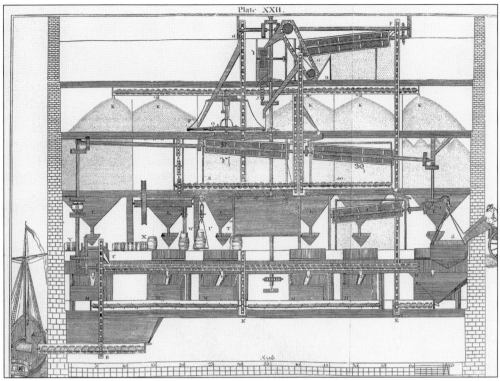

The charcoal required for the iron manufacturing process placed a heavy demand on local timber resources, and within a generation led to significant deforestation and a decline in the area's iron industry. John Ballendine's operations eventually passed through several hands until, by the end of the 18th century, they belonged to the Quaker Nathaniel Ellicott. Taking advantage of the spread of wheat cultivation in the backcountry, Ellicott converted the Occoquan works to milling operations. His main, or Merchants' Mill, was advanced for the time, with elevators and conveyors making it perhaps the first automated mill in the country. Above is a diagram explaining how the mill worked, the photograph below shows the mill in operation. (Above courtesy Oliver Evans, *The Young Mill-Wright and Miller's Guide.*)

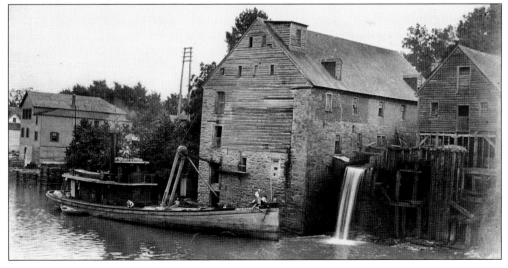

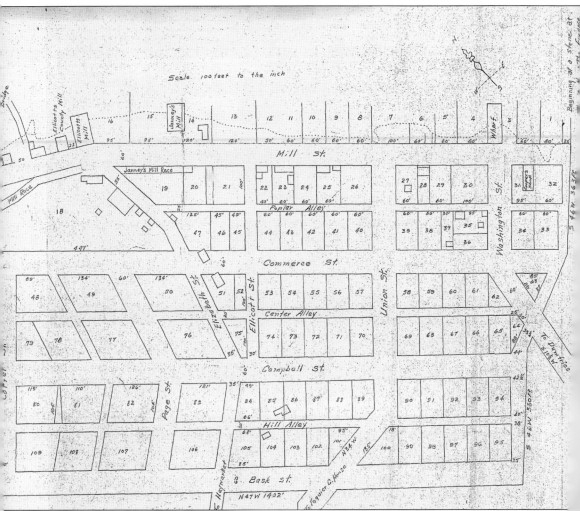

In addition to operating the mills, Nathaniel Ellicott also made other significant contributions to Occoquan's growth. After having obtained the permission of the Virginia Assembly in 1795, Ellicott two years later completed a wooden toll bridge across the Occoquan River. This put the settlement at Occoquan in direct competition with nearby Colchester, which had constructed a similar bridge less than 2 miles downriver. Later, in 1804, Ellicott and two business partners, James Campbell and Luke Wheeler, laid out the town of Occoquan on 31 acres the three owned. Having constructed a bridge and chartered a town, Ellicott then proceeded to build a road that bypassed Colchester and passed through Occoquan on its way to Dumfries. Above is a copy of the 1804 plat for the Town of Occoquan; the layout of the town's waterfront looks much the same today. (Courtesy Dolores Elder.)

The Ellicotts left Occoquan for Alexandria in 1816, but another Quaker family, the Janneys, soon became prominent. Joseph Janney Jr. took ownership of the Merchants' Mill, and in 1828 he and John H. Janney sold some of their property to Samuel M. Janney and Samuel H. Janney. These last two built a cotton mill just to the west of the Merchants' Mill. Consistent with assuming responsibility for the major mill operations in town, Janney family members also purchased Rockledge mansion. Unsuccessful in business, Samuel M. Janney left Occoquan in 1839 and devoted his attention to various anti-slavery activities. Above and at right are receipts from Janney's mill dating from 1834.

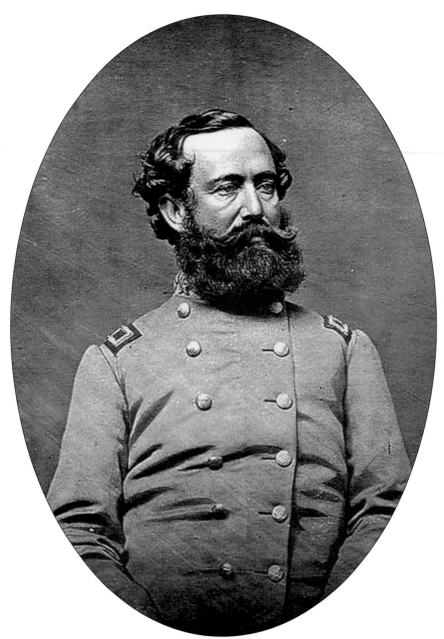

Occoquan was the site of several small engagements during the Civil War, the most prominent of which were two Confederate cavalry raids in December 1862. The first occurred on December 18, when three columns of Confederate troops totaling nearly 500 men and under the overall command of Gen. Wade Hampton (pictured above), entered the town via Washington Street, Tanyard Hill Road, and Old Occoquan Road—the last no longer exists—surprising and seizing some 20 Union supply wagons. A second raid occurred on December 27 and 28, when Hampton, this time operating under the orders of Major Gen. J. E. B. Stuart, sent more than a hundred men into Occoquan along Washington Street, driving back the Union pickets, dispersing several hundred Union cavalry, and capturing 19 prisoners and a small number of wagons. Col. John Mosby participated in the second raid. (Courtesy Library of Congress.)

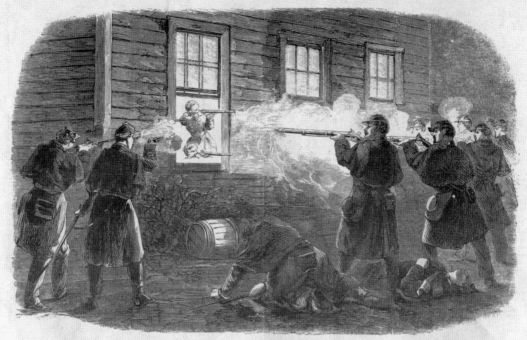

BLOODY FIGHT AT OCCOQUAN, VIRGINIA.—[Sketched by Mr A. R. Waud.]

The *Harper's Weekly* illustration above entitled "Bloody Fight at Occoquan, Virginia" depicts an event that actually occurred on the north shore of the river in January 1862. During the raid, Union soldiers pursued a man believed to be illegally running mail across the Potomac River. *Harper's Weekly* reported the capture of the man, as well as the killing of 29 "Texan Rangers." Other Civil War–related events that occurred in or near Occoquan included the stationing of Confederate Gen. Wade Hampton's men on the south bank in late 1861, the placement of more than a dozen Confederate guns on the hills above Rockledge, and the foray of the USS *Stepping Stones*, a converted New York ferryboat, which sailed up the Occoquan and fired a shot over the town on December 11, 1861. Confederate troops also used the current site of Mamie Davis Park for training purposes and on February 3, 1862, men of the Third Michigan fired upon them from across the river. A snowstorm ended the brief engagement.

21

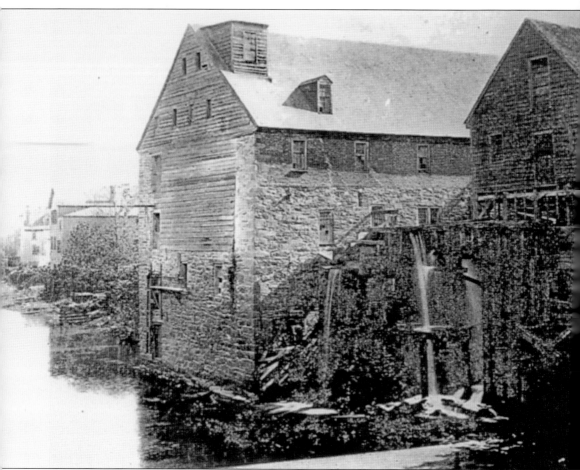

No bridge across the lower Occoquan River existed during the Civil War; the one in the town is believed to have been destroyed before the war began. Despite the absence of a bridge and the presence of fords to the west, the town of Occoquan nevertheless remained a transit point across the river during the war, hosting a ferry at times, as well as pontoon bridges. In 1863, Union troops of the 13th Vermont camped near the town and assisted Gen. Joseph Hooker's men across the river on their way to what would be the Battle of Gettysburg. The men of the 13th Vermont found their camp along the Occoquan to be ideal. Among the names they chose for it were Camp Occoquan, Camp Carusi, and Camp Widow Violet, the last two for local citizens. Above is a photograph of the mill complex from 1863.

Two

THE RIVER AND ITS BRIDGE

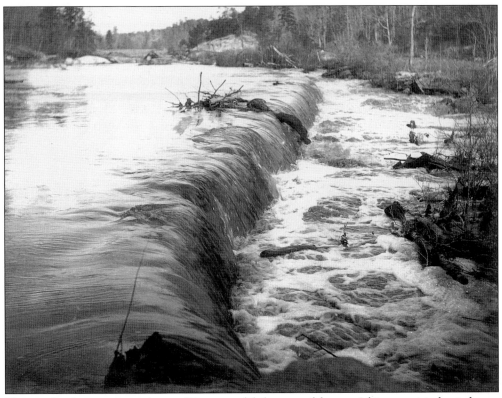

The river has been an integral part of Occoquan life for most of the town's history, critical to industry, commerce, tourism, and recreation. From origin to mouth, the river drops approximately 150 feet. More than half of this used to occur over a short series of falls just west of the town of Occoquan.

Settlement and industry brought significant change to the Occoquan watershed. Iron manufacturing and farming led to deforestation, increased erosion, and the silting of the river. Virginia's Board of Public Works directed Peter Scales to conduct a survey of the Occoquan River in 1834. That survey, which began at the confluence of Cedar Run and Broad Run, showed not forests, but hills, fields, and a few houses bounding most of the river. Scales also noted the presence of at least seven mills, three fords, and several old dams before even reaching the river's main falls west of town. The photograph above shows a fish ladder on the Occoquan. Below the Occoquan lower dam stretches across the river.

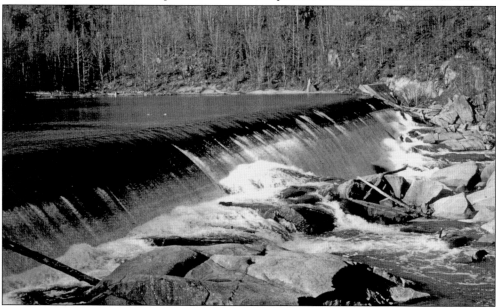

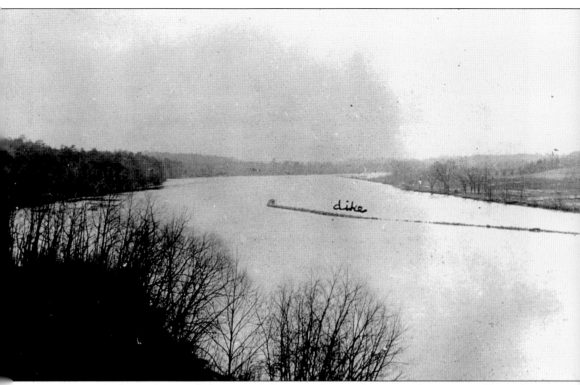

dike

Erosion, ice, timber, refuse, and the normal flotsam of a river have posed a variety of hazards to navigation on the Occoquan, which is tidal up to the fall line. In the late 19th century, the federal government stepped in to improve conditions on all navigable waterways of the United States. The resulting legislation, known generally as the Rivers and Harbors Act, is one of the oldest federal environmental laws in the country, and spawned a series of similar subsequent enactments. Under the auspices of these acts the U.S. Army Corps of Engineers submitted regular reports to Congress on the state of navigation and needed improvements on a wide variety of rivers, including the Occoquan. Shown in the photograph above is a stone dike constructed in 1880 on the Occoquan River. This dike protected vessels docked at town from ice floes and other debris coming down the river.

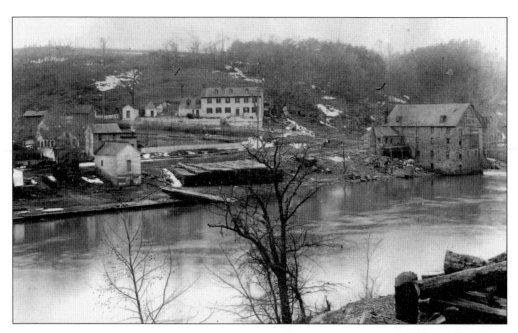

The town of Occoquan's primary residences and businesses have until recently always lain near the river. These two late 19th-century photographs provide a view of the town from the north shore, or Fairfax County side, of the water. Each photograph contains prominent landmarks from Occoquan's history. In the photograph above, one can see on the right the main mill with the attached miller's office, now referred to as the Mill House, while closer to the center sits Rockledge, which at this time had painted wooden planks covering its rock walls. Below one can see other recognizable Occoquan structures, including Tyson Janney's warehouse, the spire of the First Methodist Church, the Alton Hotel, and the Hammill Hotel.

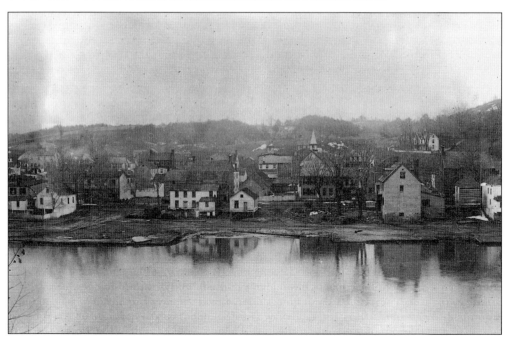

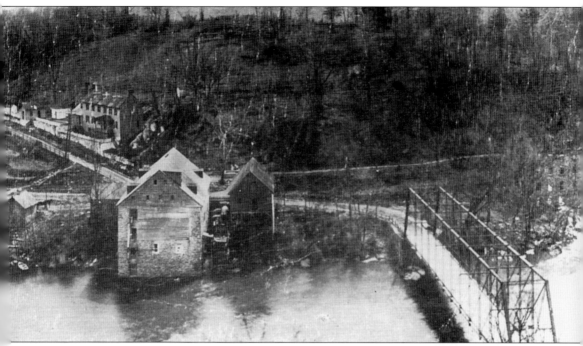

Although there were several fords across the Occoquan to the west of the main falls, businessmen recognized that the area's prosperity would benefit from reliable means of traversing the river nearer its mouth. Rangers along the Potomac path had used ferries to cross the Occoquan since the middle of the 17th century, and as the end of the 18th neared, two existed—one operated by the Mason family near Colchester and another operated by Col. John Hooe nearer the settlement at Occoquan. Using fixed ropes, poles, or oars, these ferries were the primary means of crossing the river until 1797, when Nathaniel Ellicott and Thomas Mason built competing bridges at Occoquan and Colchester, respectively. These wooden bridges were, of course, vulnerable to nature's ravages. Ellicott's was destroyed in 1807 and then again likely sometime in the decade before the Civil War. The photograph above, taken sometime before 1890, shows the 1878 iron Pratt truss bridge built across the Occoquan in approximately the same spot as Ellicott's original toll bridge.

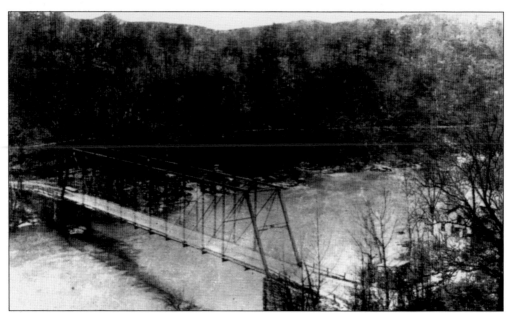

The 1870s marked the beginning of large-scale construction of iron truss bridges. Thomas and Caleb Pratt invented one of the most popular designs in 1844. Pratt bridges had an upper element in compression and a lower element in tension, each connected to the other by vertical and diagonal members. This enabled the bridge to traverse spans in excess of 200 feet. Occoquan's 1878 iron Pratt truss bridge played a critical role in the town's history. Constructed by the King Iron and Bridge Manufacturing Company of Cleveland, Ohio, it stood for almost a century. In the photograph of the bridge above, the millrace can be seen in the background above the south bank. Below one sees not only Occoquan, but also the development astride the bridge on the Fairfax side, including Lucien Davis's Bar Room.

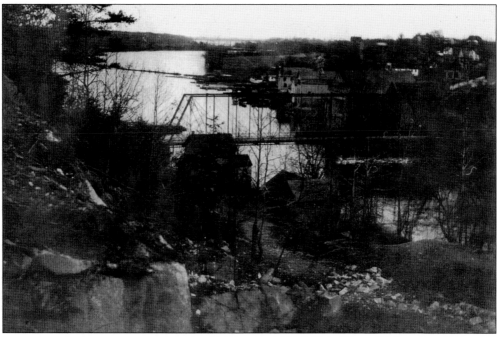

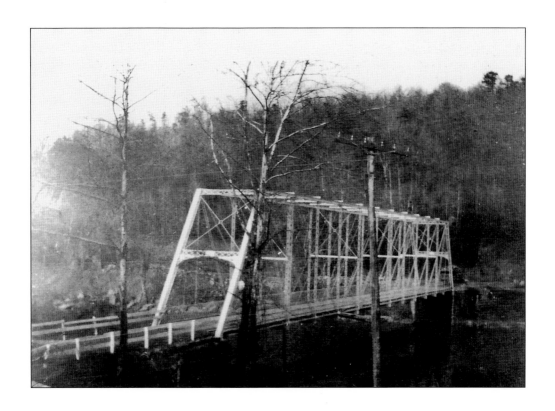

A bridge near his mills was critical to Nathaniel Ellicott's plan to draw traffic away from Colchester and through the new town he hoped to create. With the bridge and town in place, Ellicott began construction of a new road that connected with the old one above Pohick Church. By 1805 Ellicott had used this new road to divert the stagecoach and mail routes between Alexandria and Dumfries away from Colchester and through the town of Occoquan. This placed Occoquan on the great mail route between Washington, D.C. and the South. When a storm in 1807 destroyed both Ellicott's bridge and the one at Colchester, the latter was not rebuilt. Occoquan remained on the East Coast's main north-south route until the coming of Route 1 in 1928. Above and below, traffic crosses Occoquan's iron Pratt truss bridge.

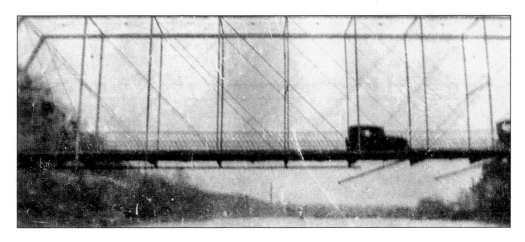

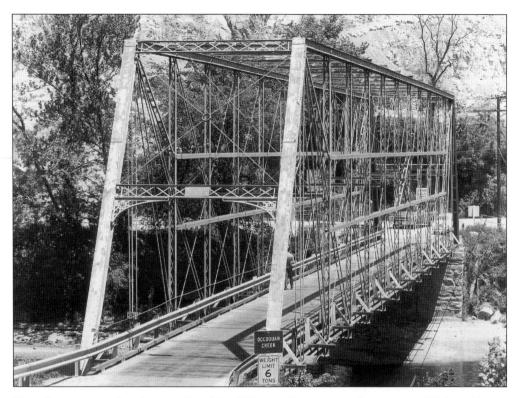

Note the signage in the photographs of the 1878 iron Pratt truss bridge above and below. Almost every map since the late 17th century referred to the Occoquan as a river until 1910, when a Fairfax County mapmaker characterized it as a creek. Thus it remained until the 1970s, when Rosemary S. Selecman launched a crusade to have the original name restored. She contacted numerous organizations, including the Department of the Interior's Board of Geographic Names. The latter recognized the strength of the evidence she had gathered and suggested that the Occoquan could once again be formally designated a river, provided the local community supported the change. And so today the town of Occoquan sits along the banks of the Occoquan River.

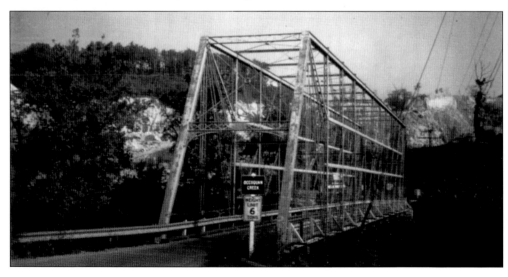

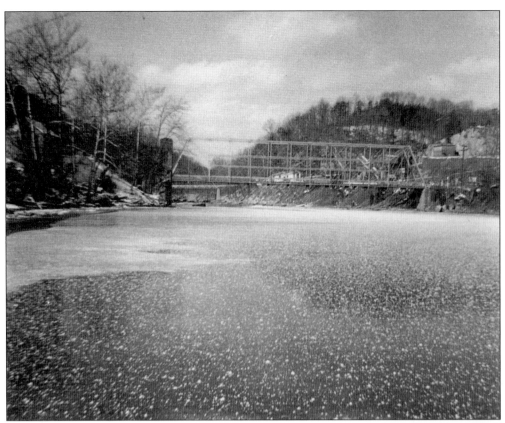

The photographs above and at right show two different personalities of the Occoquan River in winter. Above, a light snow begins to blanket the frozen waterway. As some of the town's longtime residents attest, given the right conditions, the river provided recreational pleasure even in winter, when skaters enjoyed its smooth surface. Subsequent warming temperatures brought dangers, however, as the ice broke up and the increasing current sometimes pushed slabs up along the bank. At right, ice and current churn under the bridge.

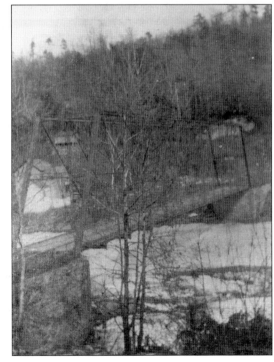

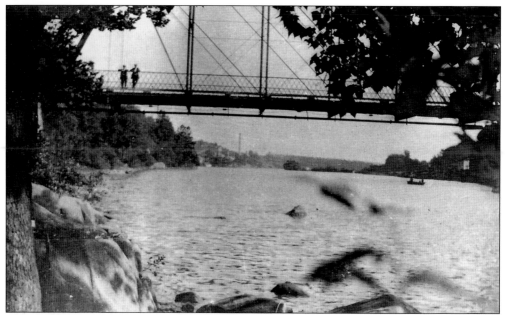

The iron Pratt truss bridge across the Occoquan also provided opportunities for leisure. Although it bore only one lane, there was sufficient room on the span for both automobiles and pedestrians to traverse the river at the same time. Above, two men standing close to the Fairfax County (or north) side of the bridge lean on the railing and gaze upriver. In the background on the right is the town of Occoquan, while on the left the stacks of the Occoquan workhouse are visible. In the photograph at left, Luella Schafer and Gordon McMahon pose on the bridge.

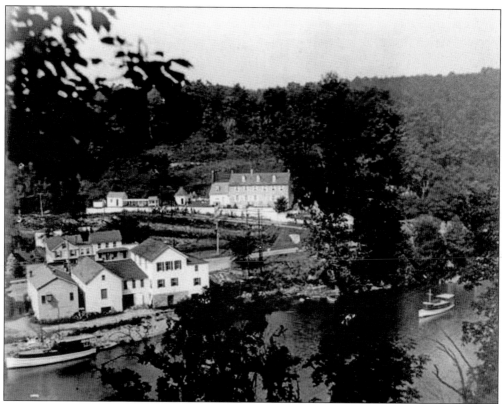

The areas surrounding the bridge offered vistas that were both developed and pristine. Above is a photograph taken around 1925 from the hills on the Fairfax County, or north, side of the river to the east of the bridge. Rockledge is clearly visible, now without wooden planking on its exterior, and two boats ply the river's waters. The large white building in the foreground on the riverbank was the Janney Apartments, which eventually burned down in 1954. Below is a photograph from farther upriver, showing how undeveloped some of the area to the west of town remained at that time.

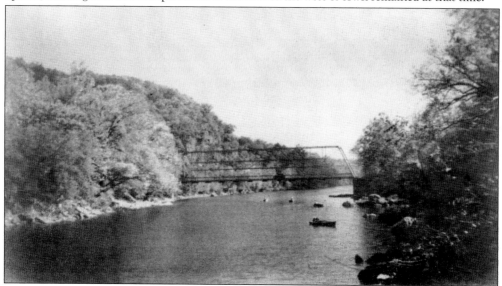

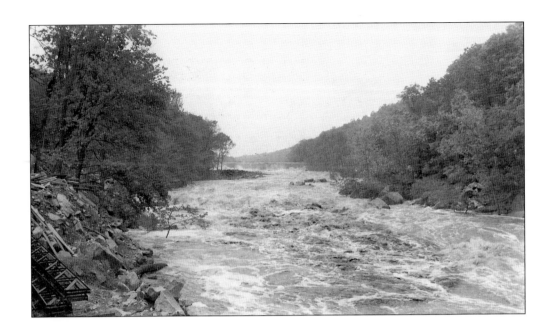

Despite all the benefits to commerce, industry, tourism, and recreation that the river has brought to the region over the centuries, its relationship with the town has not always been cordial. The river could flow with a force that was dangerous to men and women, as well as their creations. Early in the 19th century, the river wiped out the first bridges built at Occoquan and Colchester, effectively curtailing the economic future of the latter. Later it would threaten to do the same to Occoquan. Above and below, pictures from the second half of the 20th century show the river's force.

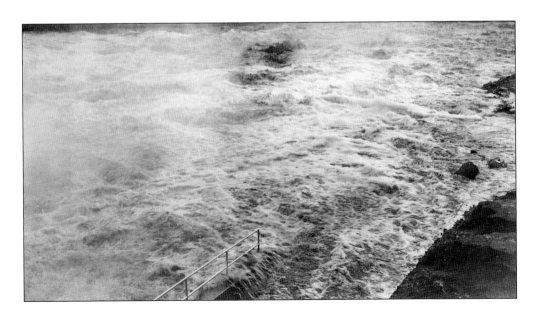

Three

INDUSTRY AND COMMERCE ON THE RIVER

For the first century and a half of Occoquan's existence, the mills at the northwest end of town served as prominent fixtures, a reminder to everyone of the town's roots. Over the years, some of the most prominent names in Occoquan history have owned the mills. Here an unidentified man passes in front of the Merchants' Mill and the attached Mill House.

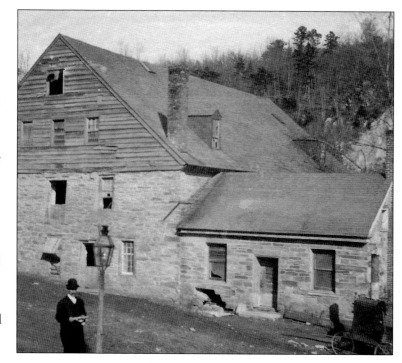

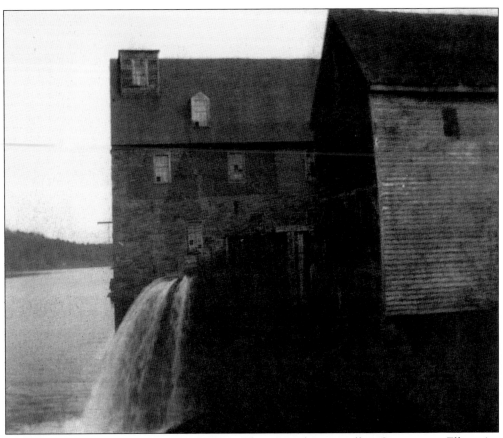

The original main mill in Occoquan—Ellicott's or the Merchants' Mill—was a two-story, 75-foot-by-45-foot stone, brick, and frame structure. No waterwheel resting in the river powered the main mill. Instead, a race directed water diverted from upriver along the south bank into holding tanks situated across the street from the mill. When needed, an operator raised the gates on the tanks; the water flowed through a conduit under the street, emerging with force at the riverbank to power the mill. Above is a photograph of the mill in operation. At left is the millrace, which remained in existence until the middle of the 20th century.

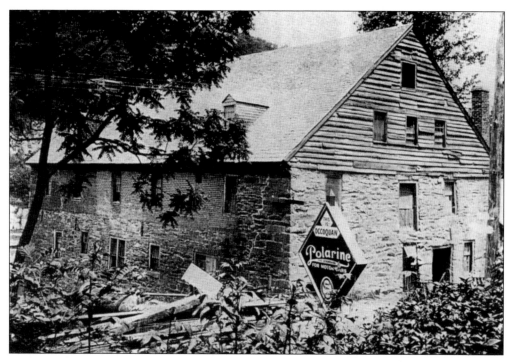

The main mill, or Merchants' Mill, continued to be used in some fashion into the 20th century. In the photograph above, a Polarine Motor Oil sign welcomes travelers who had entered Occoquan by crossing the bridge on what was still at that time the main route across the river. Work in the mill effectively came to an end in 1924, when a fire at the local power company gutted the building. Below is what remained of the mill after the fire. Although the fire destroyed the roof and walls of the main building, the Mill House, on the right, remained largely intact.

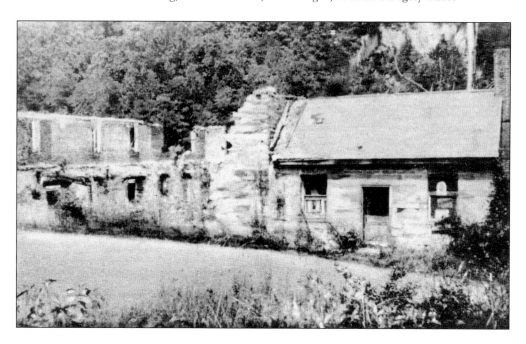

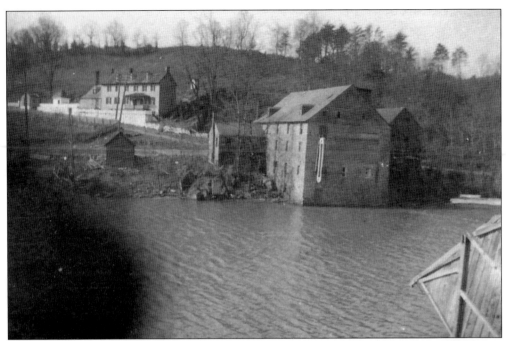

The main, or Merchants' Mill (1755–1924), was not the only mill in the Ellicott complex. Ellicott also owned a two-story wooden country mill (1757–1890), a two story wooden sawmill, a one-story wooden toll mill, and, a little farther upriver, a two-story wooden plaster mill. In the *c.* 1885 photograph above, taken from the Fairfax County side of the river, one can see Rockledge, the Mill House, the Merchants' Mill, and the Country Mill. Below is a view of some of the same structures, again around 1885, looking toward the northwest end of town. A grinding stone sits against the Mill House. Above the hill on the left are the ruins of a cotton mill or factory built by the Janney Family.

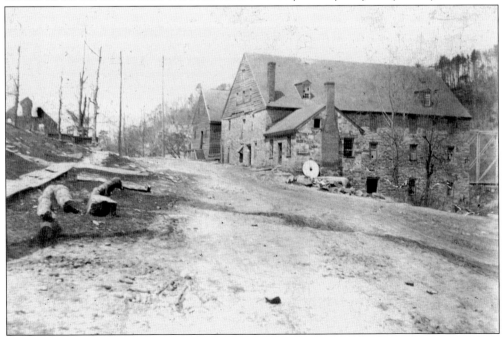

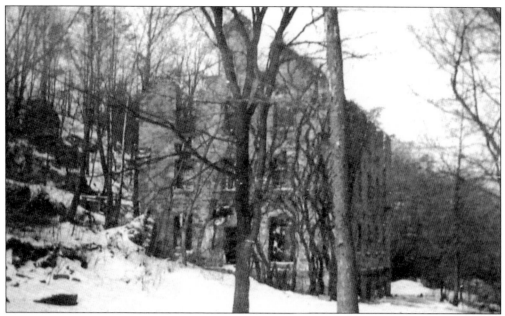

These photographs show the exterior and interior ruins of the Cotton Mill. Built by members of the Janney family in 1828, the four-story factory once stood just to the west of the bridge, and operated some 1,000 spindles. Business appears to have been difficult. One of the original owners, Samuel M. Janney, wrote that he had little knowledge of the cotton business and so was forced to rely on his employees. Eventually going broke, in 1837 he sold the business to Joseph Janney, who at that time also owned the Merchants' Mill. Operating under the rubric of the Occoquan Manufacturing Company, Joseph Janney attempted to rent or sell the operation in 1840 and 1842; it became the object of a trustee's sale a year later. In 1862, the building succumbed to arson.

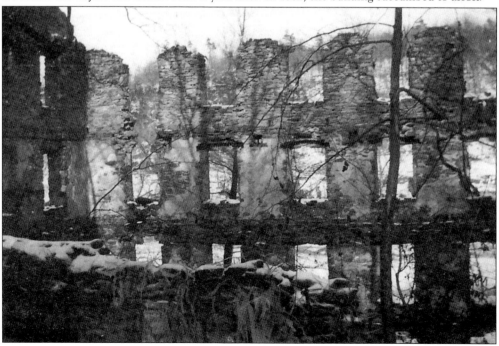

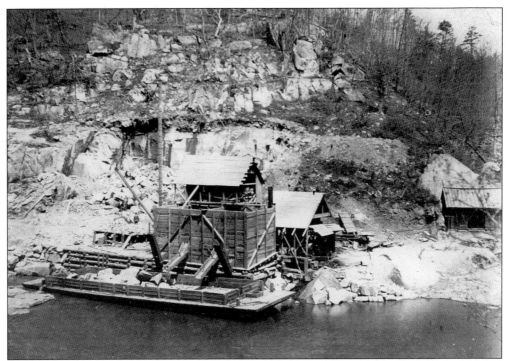

Milling was not the only industry to succeed iron manufacturing in Occoquan. For more than 150 years quarrying operations have been a part of the town's heritage. Builders used rock from along the river in constructing Rockledge, and when visiting the town in 1835, Joseph Martin commented on a quarry of valuable whetstones. Over time quarry operations on the Fairfax County side have exposed what has come to be known as "Occoquan Granite," which formed from the melting crust of the Earth some 400 million years ago. Above is a photograph of quarry operations around 1910. Below, another photograph from a later period shows work continuing along the river's bank; note the lumber pile in the foreground on the south shore.

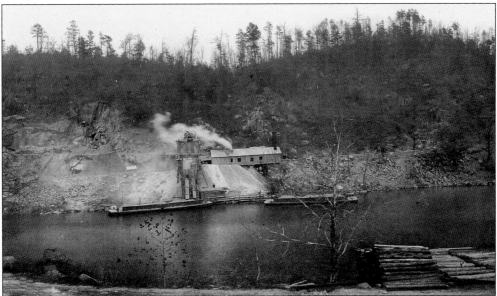

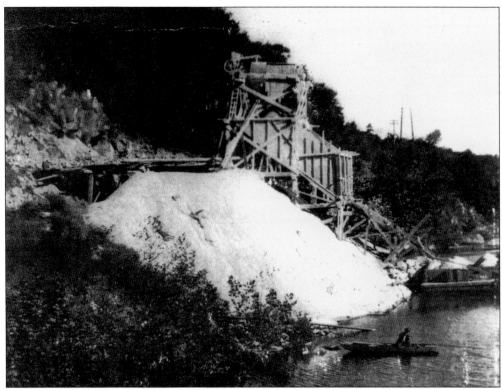

Although the nearby quarries were sometimes underutilized, as technology advanced and river barges continued to provide convenient transport, work accelerated. In the 20th century, modern stone crushers worked late into the evening. The blasting threw debris across the river, shook structures, and shattered windows. Town residents complained and filed lawsuits, first against Consolidated Stone in 1902 and then against Graham Virginia Quarries in 1960. Relations between the town and the quarry eventually improved when Vulcan Materials Company took over operations. Above is another photograph of the early quarry in operation. Below, a quarry tug and barge tie up along the bank.

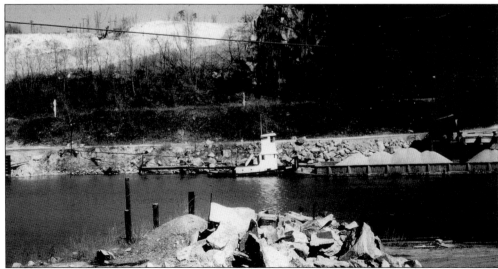

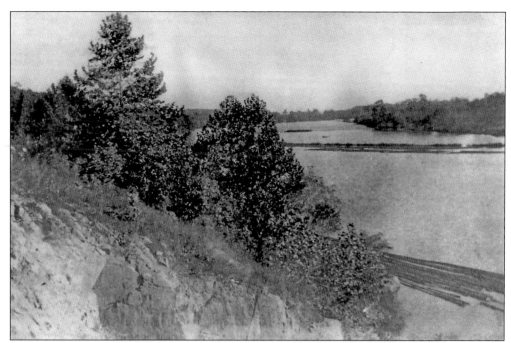

Proximity to the river made it easy not only to ship stone from riverside quarries, but also to transport lumber. From the town's earliest settlement, the timber trade flowed through Occoquan, first using the area's substantial local stands of timber, and later serving as a milling and transshipment point for material from the interior. George Washington, among others, sent his schooner to Occoquan for plank from the town's sawmills, and advertisements throughout the 19th century boasted of lumber from the town. Seen from the vantage point of the quarry, timber floats along the north bank of the Occoquan in the photograph above. Below, timber gathers against the dike in the river.

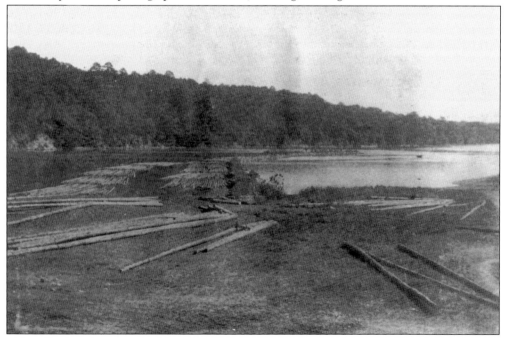

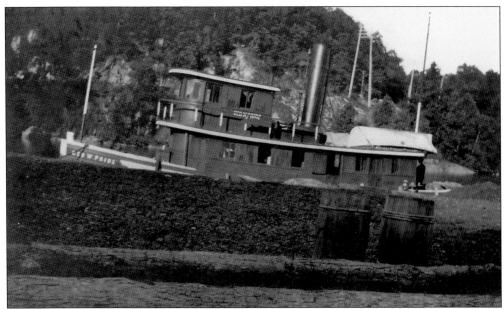

Many of the wooden piles used for the construction of bridges and wharves in the region came from Occoquan. These were generally towed in large rafts to Alexandria, Washington, and Georgetown. Longboats carried cordwood and railroad ties. On one day in 1869, some 1,000 cords lay on the bank awaiting shipment to Alexandria and Washington. W. R. Selecman advertised in the *Washington Post* in 1893 the availability of poles of any length and size, wharf timbers, railroad ties, telegraph poles, and other items. The lumber industry continued on a commercial scale in Occoquan until the end of World War II. Above and below, boats engage in the lumber trade; the photograph below was taken around 1900.

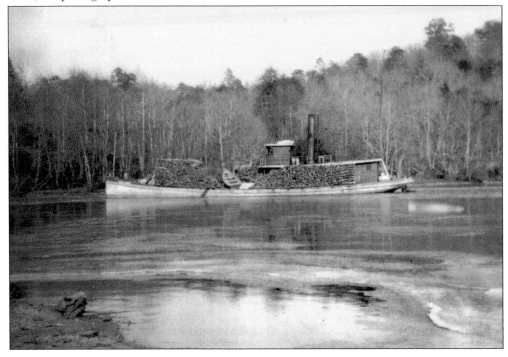

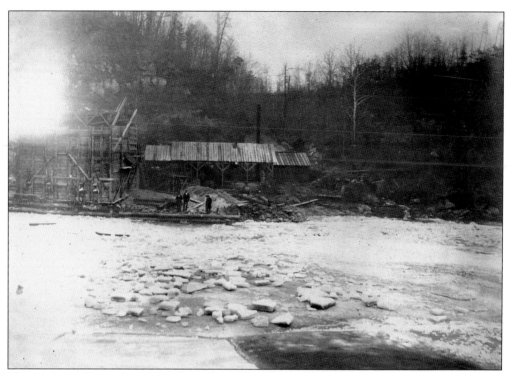

The lumber industry also had to share the river with yet other occupations. As the photographs on this page make clear, the Occoquan was also a valuable source of river ice, which was a popular commercial product for approximately 40 years beginning around 1880. Stored ice could last well into the fall if properly insulated—typically with hay or sawdust—in an icehouse. Once the river had frozen to sufficient thickness, blocks would be scored with a horse-drawn marker, cut with large saws, and then floated or moved by sled to a shed along the bank, where they were kept temporarily before transport to Alexandria or Washington, D.C.

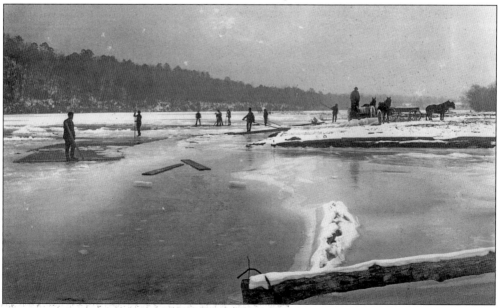

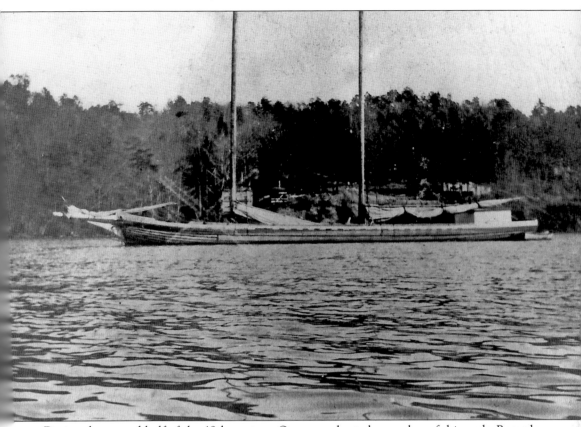

During the second half of the 19th century, Occoquan hosted a number of shipyards. Records indicate that both the Hammill and Underwood families built schooners and other vessels in town. John and Oliver Underwood opened their shipyard in 1854 and constructed vessels in a variety of lengths. Some of these included the 81-foot *Mary Ann Shea*, the 78-foot *Osceola*, the 70-foot *Belmont*, the 51-foot *Kate*, and the 33-foot *Billie Buck*. Among the more well known of the local steamers was the *Mary Washington*, which was built in Occoquan in 1874 by an association of local farmers hoping to bring produce to market. A steamship named *Occoquan* also plied the river, though its provenance is unclear. In 1890, the *Occoquan* sank in the Occoquan River during a December storm. Floated and repaired, she continued in service until 1901, when she caught fire and burned. Above is a photograph of an unknown two-masted vessel on the Occoquan River.

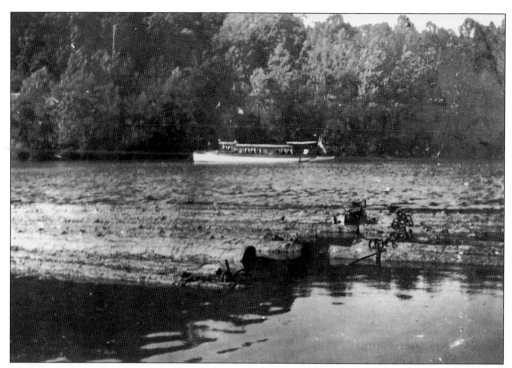

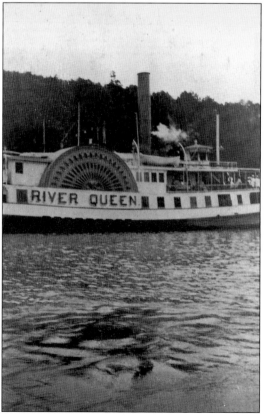

In addition to industrial and commercial traffic, the Occoquan River was once also a significant destination for excursion and recreational vessels. The *Mary Washington* was an example. Like other vessels originally constructed for cargo, the *Mary Washington* found its calling as an excursion boat, making regular trips from Washington to Occoquan in the 1880s during the summer months. Leaving in the morning from the Seventh Street wharf in Washington, D.C., the *Mary Washington* took patrons on a leisurely trip; they could dance while en route, and eventually disembarked in Occoquan for a pleasant stroll along the millrace. Above, an excursion boat cruises the Occoquan; at left, another of a different sort does the same.

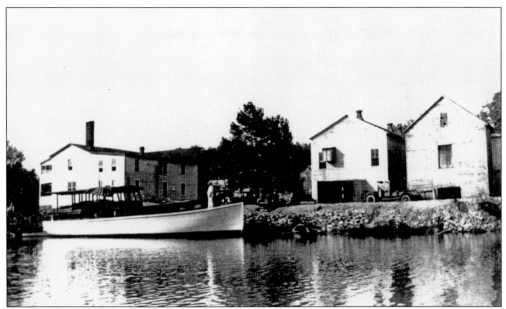

Occoquan was a riverboat excursion destination into the 1920s. Excursion boats, however, where not the only means of enjoying the river. Over the years residents and others have used their own vessels to take advantage of what the river has to offer. Above is a photograph of the *Avalonte II*, owned by the prominent Occoquan doctor, Frank Hornbaker. Tied up on the south bank of the river, one can see behind it the rear of Occoquan's Lyric Theater. The town was also a popular destination for local yacht clubs. In the photograph below, a variety of vessels dot the landscape. The transom of the boat on the near left shows that this particular craft hailed from Washington, D.C.

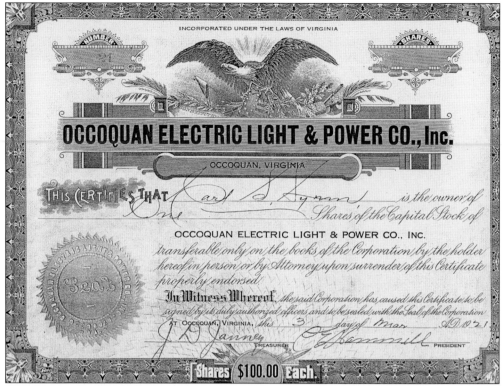

INCORPORATED UNDER THE LAWS OF VIRGINIA

OCCOQUAN ELECTRIC LIGHT & POWER CO., Inc.

OCCOQUAN, VIRGINIA

THIS CERTIFIES THAT _Carl S. Lynn_ is the owner of _One_ Shares of the Capital Stock of

OCCOQUAN ELECTRIC LIGHT & POWER CO., INC.

transferable only on the books of the Corporation by the holder hereof in person or by Attorney upon surrender of this Certificate properly endorsed.

In Witness Whereof, the said Corporation has caused this Certificate to be signed by its duly authorized officers and to be sealed with the Seal of the Corporation AT OCCOQUAN, VIRGINIA, this 3 day of Mar A.D. 1921

TREASURER PRESIDENT

Shares $100.00 Each.

With the dawn of the 20th century, electrical power came to Occoquan. Established in 1921, the Occoquan Electric Light and Power Company provided electricity to more than 24 structures in town. It was, however, to be a relatively short-lived venture. A generator mishap in 1924 caused a fire that burned down the Merchant's Mill and contributed to the company's demise. Fire damaged not only the main mill, but the attached Mill House, as well. The latter continued to deteriorate over the next two decades until it was repaired by the local water authority. Above is a share certificate of the Occoquan Electric Light and Power Company. Below is a photograph of the Mill House taken in 1949. (Below courtesy of Fairfax Water.)

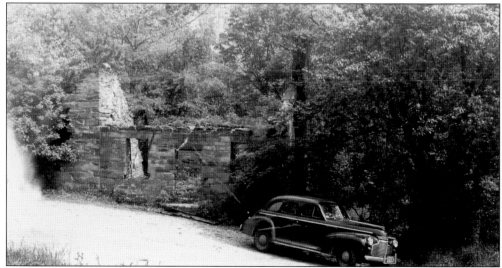

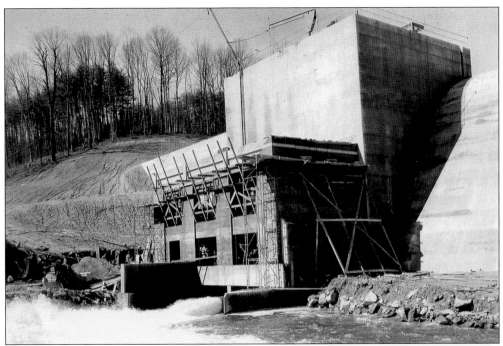

One of the most significant changes to affect the town of Occoquan occurred in the middle of the 20th century, when the Alexandria Water Company decided to construct a major dam on the Occoquan River. Since at least the time of European settlement in the area, dams had always been a part of life along the river, but this new project was to be something different—a modern, 20th-century, state-of-the-art facility like nothing the area had seen in the past. Above is a photograph of the dam's main structure under construction. At right is a photograph of the keyway for the south retaining wall. (Courtesy Fairfax Water.)

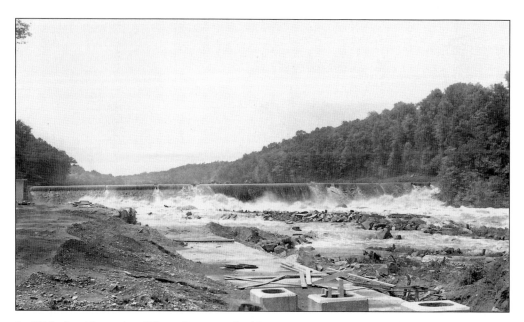

In 1913, the Alexandria Water Company had begun construction of a dam in Fairfax County at Lake Barcroft. The resulting reservoir provided 600 million gallons of drinking water for the City of Alexandria. By the early 1940s, however, population growth made it clear that additional capacity would be needed. After first building a smaller dam on the Occoquan in 1949, the company realized that a much larger dam and reservoir would be necessary, and so began construction of what ultimately became the Occoquan High Dam. Above is a photograph of the original lower dam. Below is the high dam under construction. (Courtesy Fairfax Water.)

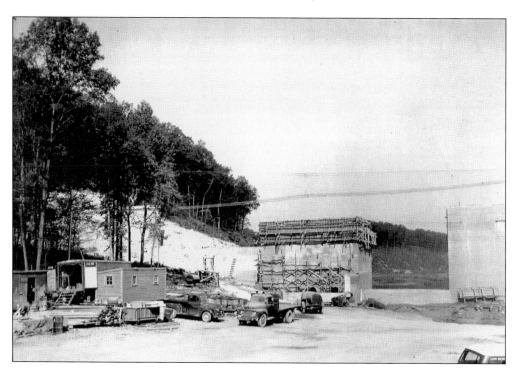

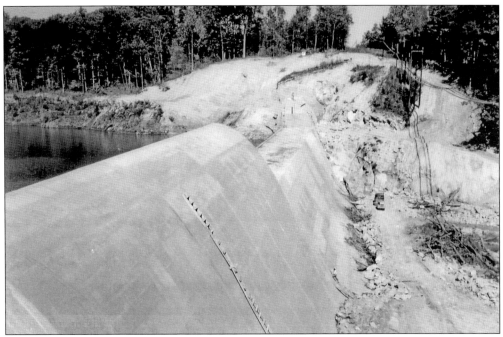

The Occoquan High Dam has never been a flood control dam. It has no gates to regulate the flow of the water; instead, water flows over the top in accordance with the height of the reservoir and the strength of the current. Though never its primary purpose, the dam once possessed the capacity to generate hydroelectric power and there were channels in the dam through which water was directed for this purpose. Now, however, the only gates the dam employs form part of the mechanism by which water is taken from the reservoir for drinking and other purposes. Above and below are additional photographs of the Occoquan High Dam under construction. (Courtesy Fairfax Water.)

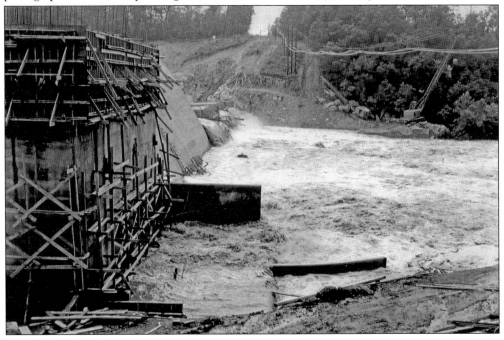

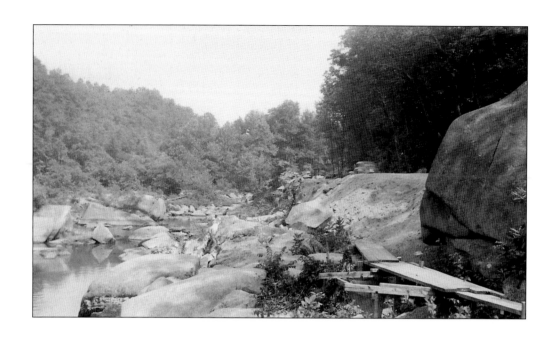

By damming the Occoquan River, the Alexandria Water Company submerged the series of falls to the west of town over which the river had historically made its rapid descent to the Tidewater. Construction also spelled the end of both the millrace and the ruins of the Cotton Mill. In addition, the Water Company property now covered the riverbank remains of the original 18th-century ironworks. Above, during construction, cars travel a roadway along the bank. Below, workmen engage in the task of damming the Occoquan. (Courtesy Fairfax Water.)

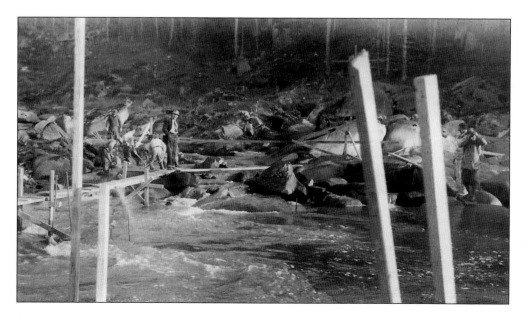

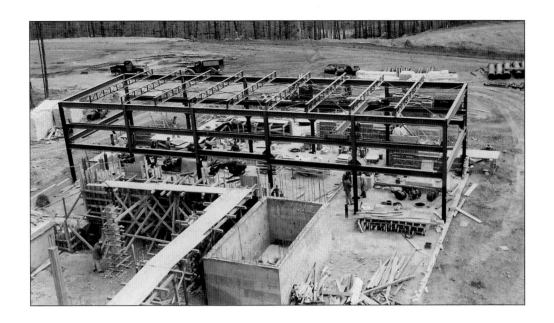

Along with the construction of the dam, the Alexandria Water Company also built a new water treatment facility just to the northwest of the town beyond the iron truss bridge, on property that straddles the boundary between the town and Prince William County. Another state-of-the-art facility for its time, the complex included large water holding tanks, which rose above the south bank of the river behind a concrete retaining wall. A transmission pipe brought water from the reservoir down to the treatment facility. Above is a photograph of the water treatment facility under construction. Below is a view of the completed facility from over the water storage tanks. (Courtesy Fairfax Water.)

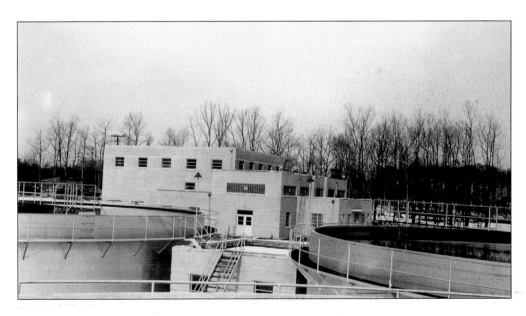

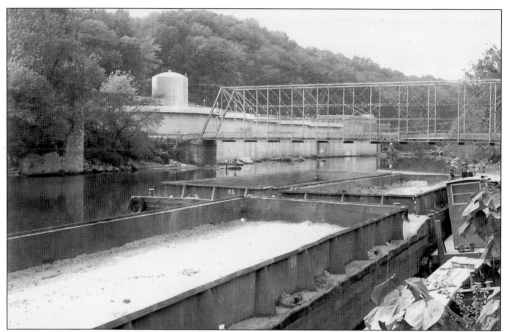

In 1967, the Fairfax Water Authority (now known as Fairfax Water) took over the Alexandria Water Company's facilities on the Occoquan River. Occoquan's High Dam stands 65 feet high and rises 122 feet above sea level, creating a reservoir of 8.3 billion gallons of water. The original water treatment plant at the northwest end of town is no longer in operation, having been replaced by a more modern facility on the Fairfax County side of the river. Above is a 1968 photograph of the original treatment plant from the vantage point of a quarry barge. Note the mill ruins to the left of the bridge. Below is an aerial photograph of the Fairfax Water facilities and a portion of the town. (Above courtesy Vulcan Materials Company, Inc.)

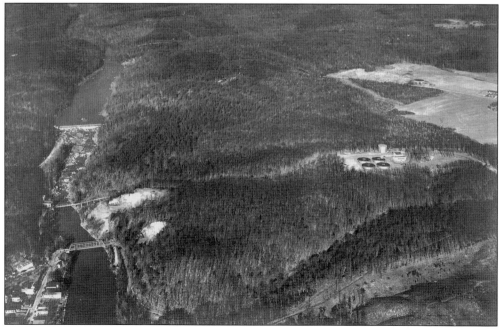

Four

THE TOWN AND
ITS PEOPLE

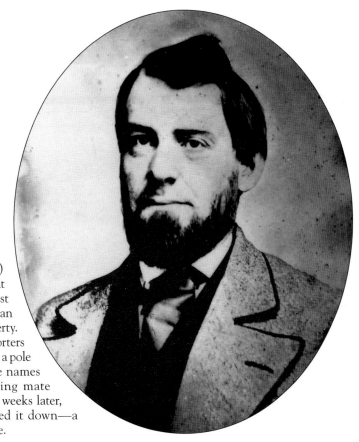

Joseph T. Janney (1832–1882) was a member of a prominent local family. One of the most interesting events in Occoquan history occurred on his property. There, on July 4, 1860, supporters of Abraham Lincoln erected a pole with pennants bearing the names of Lincoln and his running mate Hannibal Hamlin. Several weeks later, the county militia chopped it down—a harbinger of things to come.

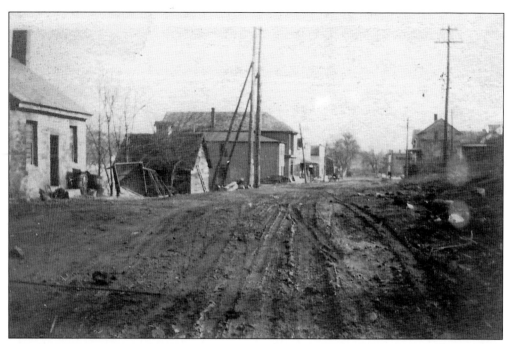

Mill Street has always served as Occoquan's main thoroughfare. Running closest to and parallel to the river, it has retained its name since being identified on the 1804 plat. In fact, many of Occoquan's streets have retained their original names, including Washington, Commerce, Union, and Ellicott Streets. Others, however, such as Coffer, Campbell, Page, and Back Streets have disappeared. The photograph above provides a look down Mill Street from the northwest end of town. Note the Mill House on the left. Below, a c. 1900 photograph shows a similar view of Mill Street from a slightly different perspective. Two horse-drawn carriages approach and a lamp adorns the road's south side.

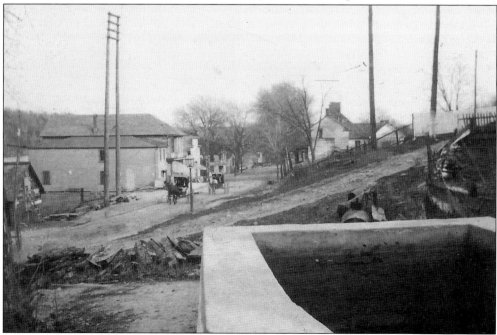

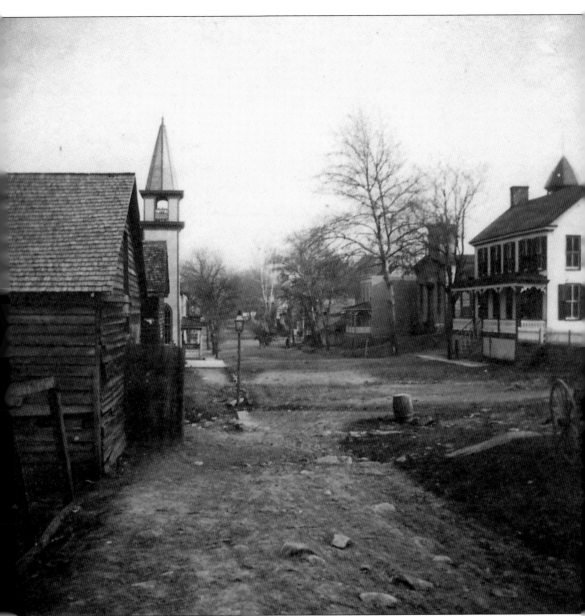

Commerce Street has also always been one of Occoquan's signature avenues. Like Mill Street, it was identified on the 1804 plat, which shows it crossing, from east to west, Washington, Union, Ellicott, and Elizabeth Streets. All of these but the last remain today. Elizabeth Street is now the brick driveway fronting Rockledge mansion. Commerce Street emptied on to the main road that led south to Dumfries. The photograph above is looking down Commerce Street to the southeast. The building on the right is recognizable today. Just visible above the peak of its roof is the bell tower of the Occoquan schoolhouse. On the left is the front and spire of the First Methodist Church, one of Occoquan's earliest congregations. Again, a street lamp sits adjacent to the road on the north side. In the distance, a rider crosses the street.

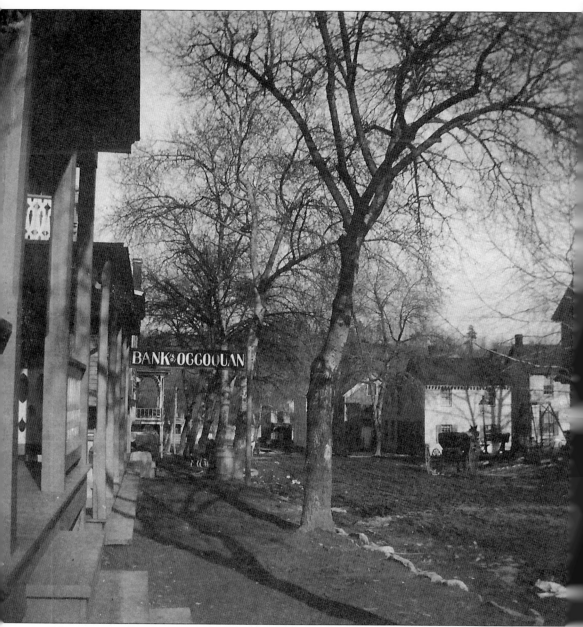

Union is one of Occoquan's main north-south streets, along with Washington and Ellicott Streets. Also identified on the 1804 plat, the street began at its intersection with Mill Street, and while heading south crossed, as it does today, Poplar Alley, Commerce Street, and Center Alley. Its exit from town to the south led to Fauquier County, after crossing the platted but now non-existent Campbell Street, Hill Alley, and Back Street. A tanning yard once sat on Union Street's east side as it left town. This ultimately provided the name for Tanyard Hill Road, which currently links Union Street with Old Bridge Road. The 1915 photograph above looks north down Union Street toward Mill Street and the Occoquan River. On the left is a sign for the Bank of Occoquan. After its destruction by fire in 1916, owners rebuilt the bank on Mill Street.

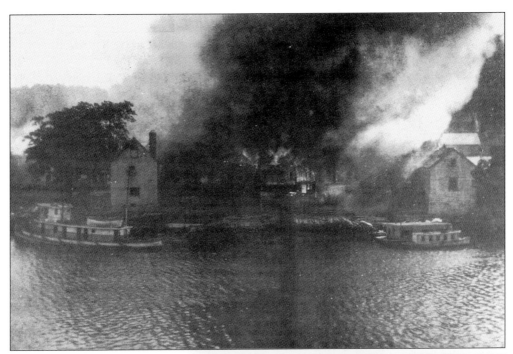

Fire devastated Occoquan in 1916. Allegedly an oil-stove explosion started a blaze in the former Alton Hotel. Sweeping through town, the fire damaged numerous structures. A diary entry from Helen Davis, a 24-year-old woman living in town at the time, remarks that it "destroyed six dwelling houses, the bank, the Methodist church, most of the machinery belonging to the Viadex Manufacturing Company, and three or four stables." In the photograph of the fire above, one can see Tyson Janney's warehouse on the right, and what was then Ledman's Seafood House, in flames. At right is a view of Mill Street after the fire; note the ruins on the right. In 1924 the town fell victim to another fire, this one caused by the local power company; the damage from the latter, however, was limited.

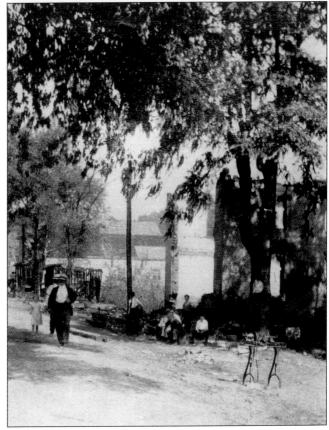

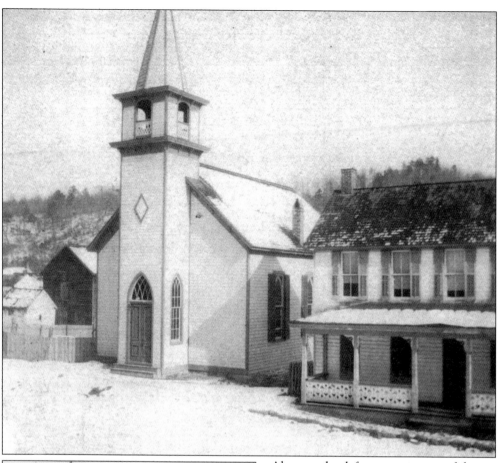

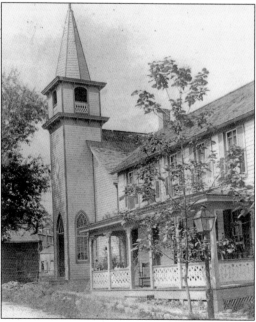

Above and at left are two images of the First Methodist Church before it was destroyed by the fire of 1916. Both views are from the south side of Commerce Street looking to the northwest end of town. In the photograph above, the hills on the Fairfax County side of the river are visible on the upper left. In the photograph at left, looking between the tree and steeple, one can make out what appears to be the face of Rockledge mansion. The Shanklin family owned the house to the right of the church. Although not rebuilt after the fire, locals eventually erected another Methodist church behind where the first had stood.

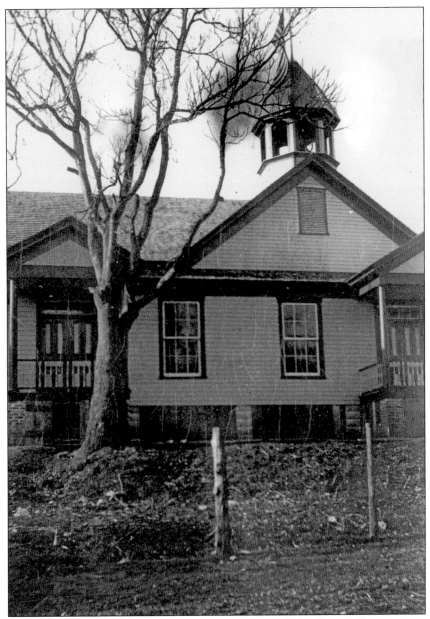

Occoquan has had several schoolhouses, the first of which was likely a small structure in which the novelist John Davis tutored the children of Nathaniel Ellicott at the start of the 19th century. Another private school existed just after the end of the Civil War. Known as Township Hall, it sat along the river on the property of the Janney family. The first public school in Occoquan opened on Commerce Street during the first decade of the 20th century. This two-room structure had separate entrances for each classroom, with one serving the first through fourth grades and the other the fifth through seventh grades. An oral history from Margaret Selecman Peters describes each room as having a large stove, windows with heavy mesh wire, and a water cooler filled from a local spring. Teachers sometimes marched students to the scales at the mill for weighing. In 1927, authorities built a new school at what is now the corner of Occoquan and Old Bridge Roads. Above is a photograph of the Occoquan School building on Commerce Street.

In the 19th century, the corner of Commerce and Union Streets hosted the Hammill Hotel. Situated at 206 Union Street, the building took its name from Hugh Hammill, who had inherited the property from John Athey in 1866. Silas Beach likely operated a tavern out of the building in the early 1830s, before selling to Athey. Hammill's son Edward appears to have been responsible for the hotel's operations and in 1878 purchased the property. At the start of the 20th century, Arthur Gardner bought the hotel, which was then known as the Gardner House until 1927. Later it was run as an inn, and in 1942 opened as the Beachwood apartments. Tradition asserts that Confederate officer Wade Hampton used the structure for his headquarters during the winter of 1861/1862.

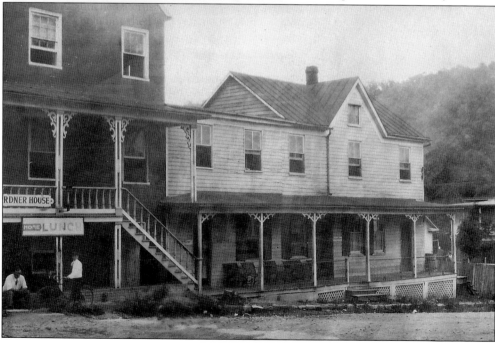

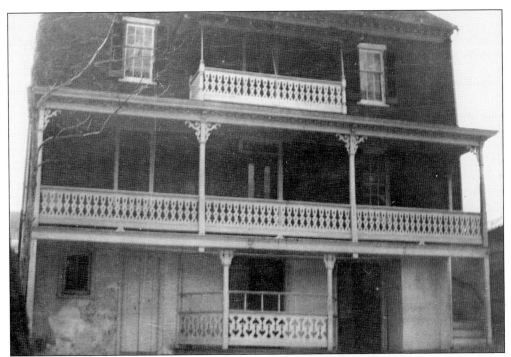

The Alton Hotel on Mill Street was another prominent Occoquan establishment that welcomed travelers. Contrary to widely held belief, the Alton Hotel—not the Hammill—was probably the first brick building in town. Constructed originally as the home of William Selecman in 1804, it stood on the south side of Mill Street between Union and Ellicott Streets. Before the 20th century, Lycurgus and Luvinia Ledman ran the home as the Alton Hotel. At the time of the 1916 fire, a Mrs. Weedon lived in the building; the fire, which reportedly originated at the Alton, destroyed the structure.

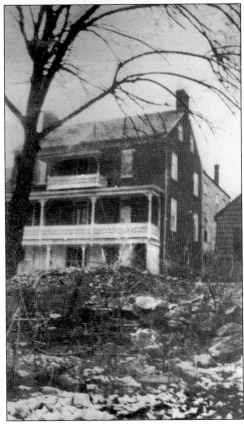

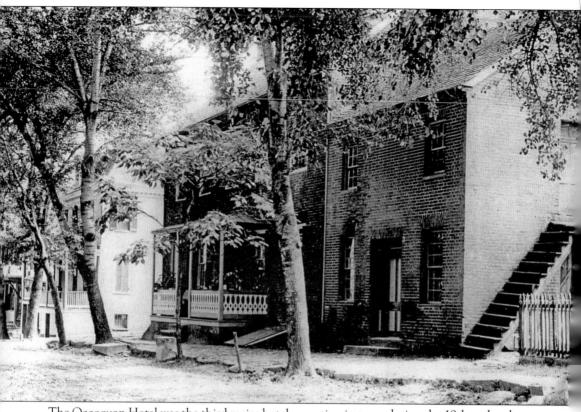

The Occoquan Hotel was the third major hotel operating in town during the 19th and early part of the 20th century. John Tayloe III purchased three lots in Occoquan in 1814; on a lot fronting Mill Street he built the hotel. After having served as a county postmaster for a time, Tayloe subsequently aggressively pursued mail contracts, presumably seeing them as a means to benefit his other business interests, for stagecoaches transporting mail could also transport passengers. Taking advantage of the potential synergies involved, Tayloe's stagecoach lines made stops in Occoquan, where passengers could conveniently refresh themselves at his hotel. In 1825, Tayloe sold the hotel to Michael Cleary; the fire of 1916 later destroyed the building. The photograph above is believed to show the Occoquan Hotel in the center. Note the stone to the left of the tree in the center of the photograph. Passengers used such stones to step down from the door of their carriage.

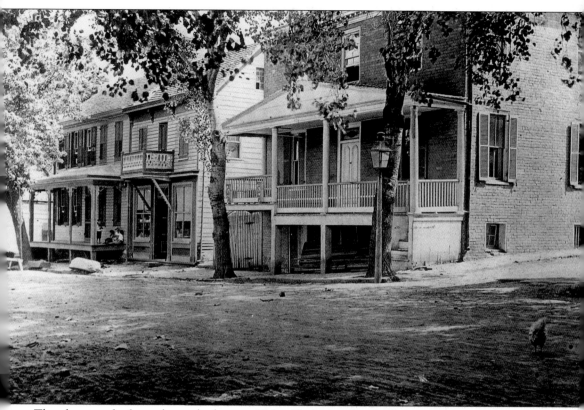

The photograph above shows the house of John Underwood on Mill Street just to the east of the Occoquan Hotel. By 1860 Underwood was a 32-year-old wheelwright, carpenter, and boat builder. He was also among the 60 men who erected a pole on the property of Joseph T. Janney on July 4, 1860, adorned with pennants containing the names of Abraham Lincoln and his running mate Hannibal Hamlin; the Prince William Militia chopped the pole down on July 27. In the presidential election the following November, Abraham Lincoln received 55 votes in Prince William County, all of which came from Occoquan. Once the Civil War began, Confederate forces held Underwood in suspicion. On one of two raids into Occoquan in December 1862, Confederate forces took captive the "noted abolitionist and traitor." To reward his loyalty after his release in 1863, Lincoln sought a position for Underwood, who soon thereafter became a U.S. marshal. Underwood's residence on Mill Street burned down in the fire of 1916.

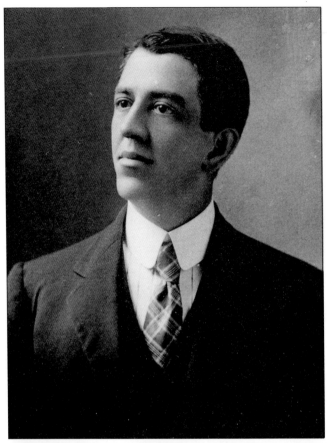

The Janney family had been prominent in Occoquan from the early 19th century. In addition to establishing the Cotton Mill, they operated the Merchants' Mill for more than a century. Tyson Janney (1866–1936), pictured at left, took over the mill after his father's death in 1882. He also opened a general store and warehouse on two parcels next to the river, just east of the mill complex. Upon marrying Helen Meta Gibson Tyson, he moved out of Rockledge to a house on Mill Street, shown below. Sometime in his fifties, Tyson Janney turned the mill over to his sons and moved to Fredericksburg, where he opened a grocery.

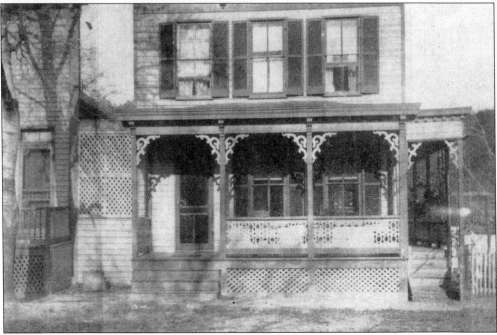

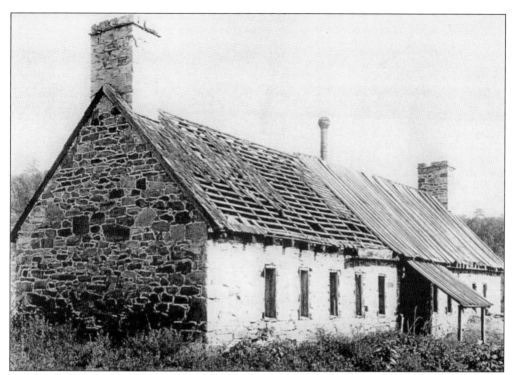

Pictured above and below are the exterior and interior, respectively, of the Occoquan Cooper's Shop. Nathaniel Ellicott operated his own cooper's shop during the years he owned the mill complex. The 1804 plat places Cooper's Alley at the far eastern end of town, and shows the Cooper's Shop between the alley and Washington Street, with frontage on Mill Street. Given the extensive river commerce on the Occoquan and the corresponding need for barrels, the demand for a cooper must have been substantial at times. Census figures from 1870 list 16 coopers in Occoquan, with nine of them from two families.

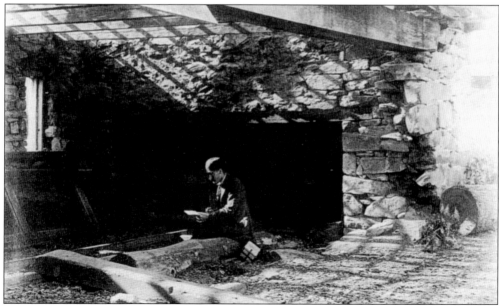

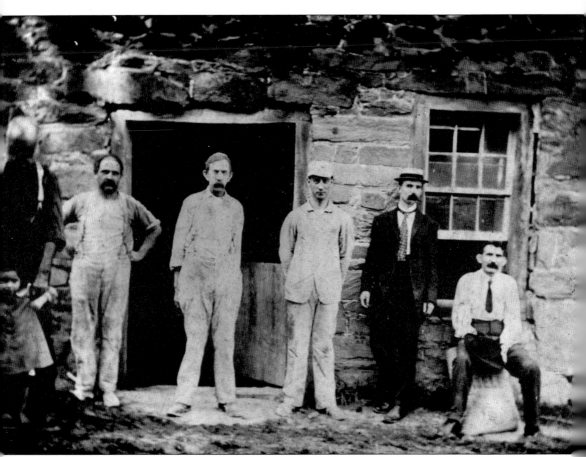

Among the photographs of Occoquan residents at work are a few that show them taking a temporary respite from their labors. Above, standing in front of the doorway to the Merchants' Mill from left to right are Jim Tavenner with his niece Audrey Carter, Gus Brenner, John Tanner, Bourne Grimes, an unidentified man, and Will Lynn. A half door behind the men reveals that this is the entrance to the main mill itself, rather than to the miller's house, which is outside the photograph on the right. Brenner, Tanner, and Grimes appear to have only recently stopped working, while the ties on the unidentified man and Will Lynn make it unlikely that they were actually laboring in the mill proper. The Will Lynn in this photograph is likely the same Will Lynn who owned a wharf behind what is now 309 Mill Street. An oral history from James "Woody" Taylor recalls Will Lynn regularly buying railroad ties at the mill and hauling them down to his wharf to await transport by wagon or barge.

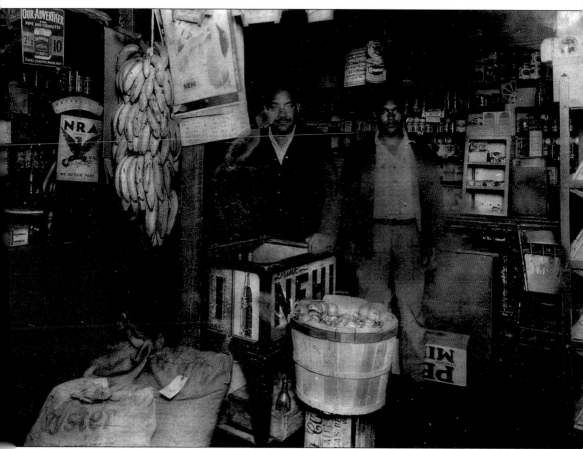

Above is a photograph from around 1940 of the inside of Ogle Harris and Sons store at 204 Washington Street, an Occoquan institution from the beginning of the 20th century until 1972. The son of a slave, Ogle Harris originally sold ice cream from his house's summer kitchen until around 1900, when the family moved into another house on Washington and Commerce Streets and converted their former residence into a full-fledged business selling groceries, meat, and produce. In an oral history from 1999, Ogle's daughter Saluka remembers the store possessed a pickle barrel and a machine that dispensed bottles of cola, root beer, orange soda, and grape Nehi. A wood-burning stove warmed the store in the winter, and visitors congregated on a bench near the front door. Ogle's son Arthur continued to run the store after his father's death, along with his wife Doris and his sister Saluka. The store closed in 1972.

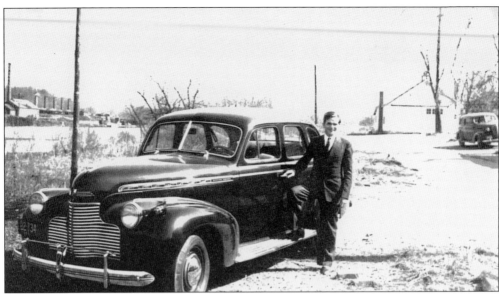

Reports allege that during the 1916 fire it took more than 40 minutes for firemen to arrive from Alexandria, the closest fire department at the time. A little more than 20 years later, in 1938, the lack of a fire department in eastern Prince William County led to the formation of the Occoquan-Woodbridge-Lorton Volunteer Fire Department (OWL VFD). Above is a photograph of Ambrose Pettelat in 1939; in the background on the right is the first OWL VFD fire station, which was located at the eastern end of Mill Street. In 1946, Leary Lumber moved out of its existing building on the south side of Mill Street between Washington and Union, and the fire department took over the structure. Shown below is this later home of the OWL VFD.

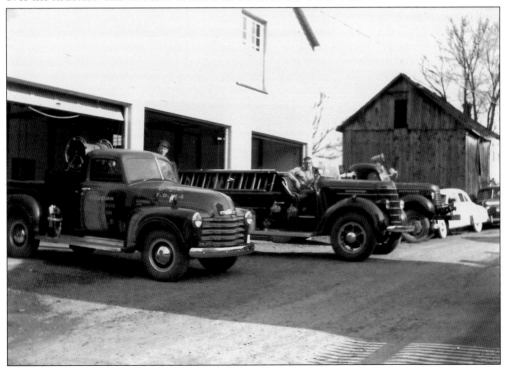

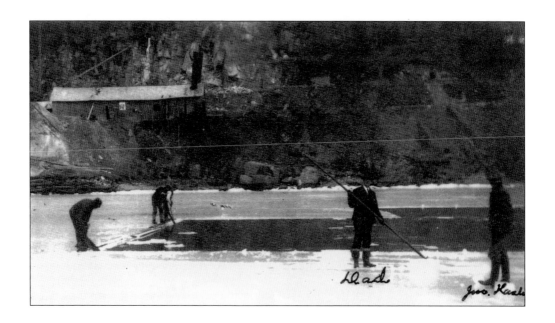

Occoquan residents also took to the river for things other than commerce, industry, and recreation. For some it was a source of winter river-ice, not just for sale, but for personal use during the area's long, hot, and humid summers. In the photograph above, some locals cut ice from the Occoquan River. Note the quarry shack in the left rear of the photograph from the period when quarry operations were underway along the river's north bank. The man labelled "Dad" is Tyson Janney. Below, during World War II, troops use the Occoquan River for training maneuvers. A pontoon bridge stretches across the river east of town.

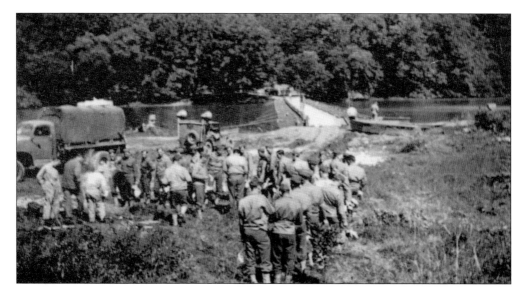

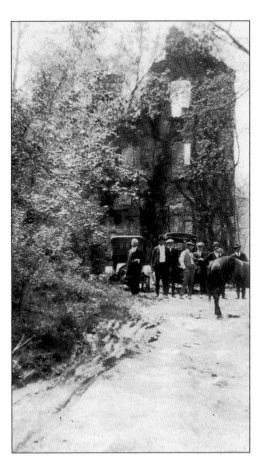

In these photographs from the early 1920s, men gather for a shad bake at the ruins of the old Janney Cotton Mill, which burned in 1862. Shad was a popular eating fish at the time. During the second half of the 19th century and the first decade of the next, the town of Occoquan's riverbanks hosted a number of fisheries and packinghouses for shad, herring, and sturgeon. Note the horse in the foreground of the photograph at left and the automobiles nearer the mill ruins. The area that once contained the Cotton Mill is now covered by Fairfax Water's decommissioned water treatment facility.

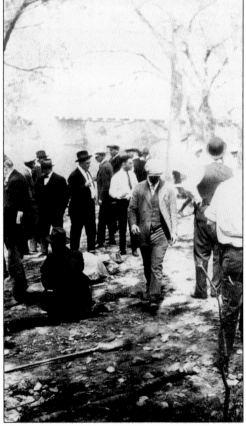

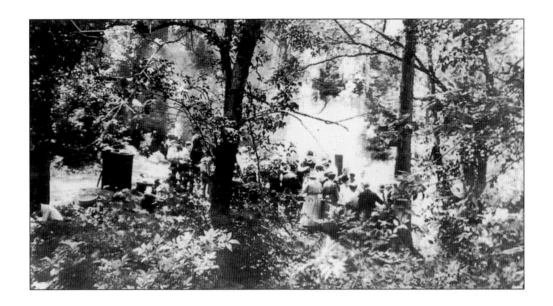

The ruins of the old Janney Cotton Mill were a popular location for a variety of events in addition to cookouts, including camping trips and visits by excursion tourists. Unlike the previous two photographs, the one above from the same 1920s shad bake at the ruins shows what appears to be a mixed gathering of men and women. Although almost everyone in all four of these shad bake photographs is unidentified, the man on the left in the photograph below with his hands on his hips is Sgt. Gene Bryant. Directly behind him is Bob Burdett, who helped supervise the planking of the shad.

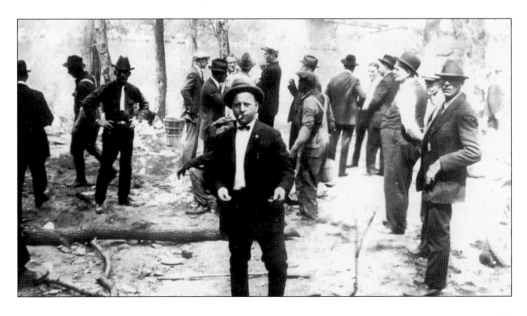

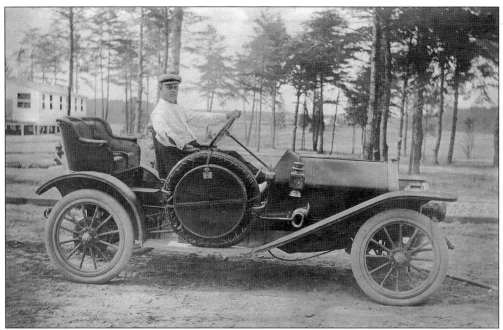

The photograph above shows the prominent early 20th-century Occoquan physician Frank Hornbaker in an automobile that was one of the first in the community. While maintaining a general practice in Occoquan, Dr. Hornbaker also served as the physician for the D.C. Work House and Reformatory across the river at Lorton from 1910 until his death in 1937. Along with his friend, the druggist Leamon Ledman, he also opened a pharmacy at 404 Mill Street in 1908. A 1933 newspaper article, in addition to praising Hornbaker's professionalism and service, noted that his pharmacy boasted "a soda fountain and many modern added services." In addition to those modern added services, Dr. Hornbaker also had two children, Mildred and Frank Jr., shown below in their daddy's car outside the Tyson Janney storefront in 1917.

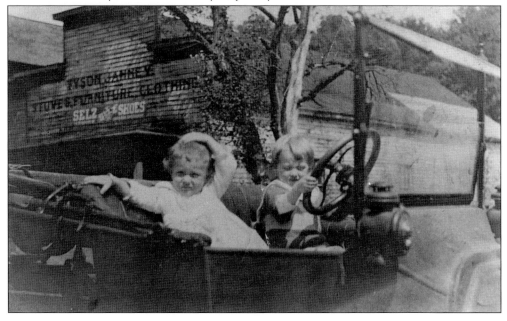

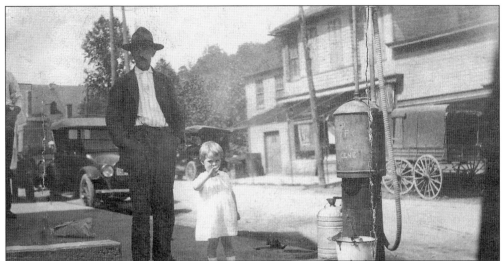

Dr. Frank Hornbaker married Grace Lynn Clarke in 1914, and until his death they shared a comfortable home on the Lorton property. Their daughter Mildred seems to have been a photogenic young girl. In the scene above, Mildred stands near a fuel dispenser on Mill Street. Unfortunately, the man standing next to her remains unidentified at the time of this writing. Note the presence of both automobiles and wagons parked along the curb. In the 1920 image on the right, Mildred again stands next to a fuel dispenser on Mill Street, this time outside the pharmacy owned by her father. Shielding her eyes from the sun, she firmly grips the collar of her dog.

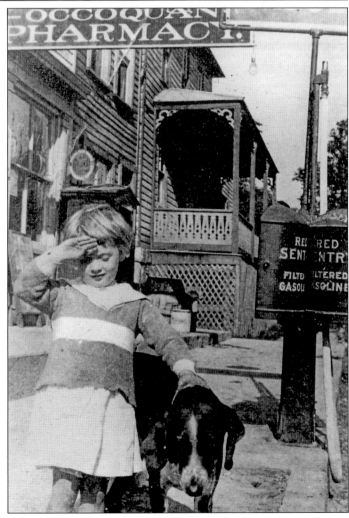

In the photograph at left, Harold Wilcher stands outside the back of Occoquan's Lyric Theatre, which Dr. Hornbaker opened in 1920. Below, Harold and a friend share a laugh outside the front of the same building, which a sign shows is playing the 1939 film *Wuthering Heights*, staring Laurence Olivier and David Niven. The Lyric Theatre was a segregated establishment. While whites sat on the main floor, blacks sat in the balcony. There were also separate entrances for whites and blacks, which forced the latter to access the concession stand from the ticket window.

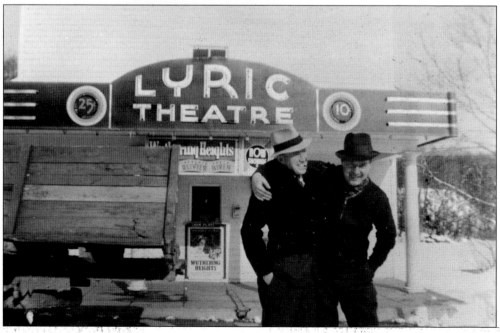

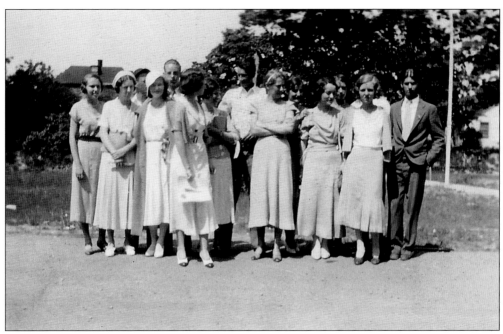

The members of the Occoquan class of 1932—attendees of the recently built school at the corner of Occoquan and Old Bridge Roads—pose for a formal picture. From left to right, they are Hazel Metzger, Evelyn Kidwell, Douglas Riley, Muriel Hicks, Frank Malcolm, Melissa Lacey, Katharine Brawner, William Pearson, Mildred Hornbaker (now grown up), Ardis Collins, Myrtle Hensley, Frances Hinton, Russell Bolton (hidden), Katherine Pearsons, and Louis Hinton. Below, just the women participate. From left to right, they are (kneeling) Mildred Hornbaker and Muriel Hicks; (standing) Katherine Pearsons, unidentified, Ardis Collins, Frances Hinton, Hazel Metzger, Evelyn Kidwell, and Myrtle Hensley.

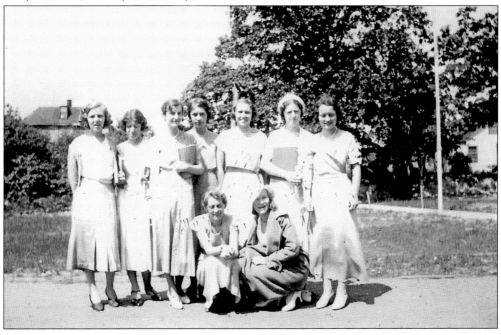

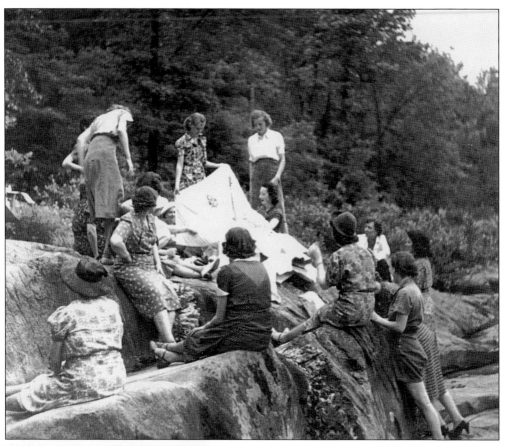

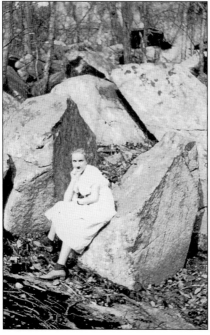

Bridal showers originated in the late 19th century and became very popular in the United States, including in the town of Occoquan. Like the ruins of the old Janney Cotton Mill, the rocks along the river in an area called "the Glen" were a popular location for such social gatherings, as well as for a variety of other recreational pursuits, including swimming and picnics. Here a number of women from town and their friends meet on the rocks for a bridal shower in 1937. The woman standing in the center of the photograph in the white blouse is Geraldine Wilcher, who sits among the rocks in the picture at left.

Fishing has always been a popular pursuit along the river's bank near the town, both for commercial and recreational purposes. In addition to the herring, shad, and sturgeon packinghouses mentioned earlier, more than a dozen fishing schooners might have been found docked at the town's wharves during the late 19th century. Early in the 20th century, there was also an oyster-shucking house and turtle farm. In the 1945 photograph above, H. T. Lohr poses in front of Janney's Drugs with a catfish he caught. At right, Ralph Turner holds a 34-pound catfish caught near Occoquan.

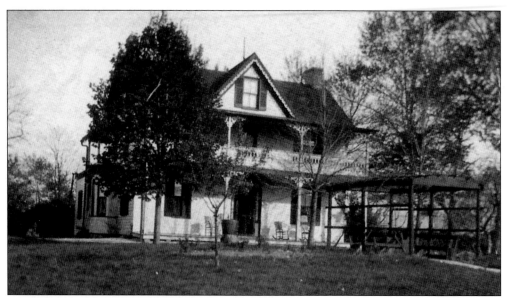

Carlton Lee Starkweather was another Occoquan physician in the early part of the 20th century. He and his wife lived in a hilltop home known as River View Cottage, where he maintained a medical office. Located on the current site of 127 Washington Street, River View Cottage had a broad lawn and offered an excellent view of the town, the river, and the hills to the north. Among the items found in the Starkweather attic by subsequent owners was a volume of genealogy on the Starkweather family from 1640 to 1898, compiled by Dr. Starkweather himself. This volume resides today in the Mill House Museum. The photograph above offers a view of the Starkweather home. Below, the Starkweathers prepare to go horseback riding.

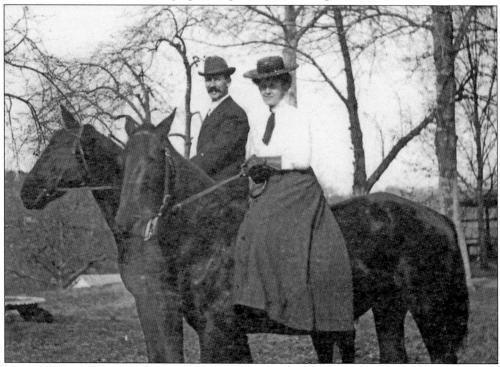

As was the case in the rest of the country, for a time, automobiles and animal-drawn vehicles competed for space on Occoquan-area roads. In the photograph at right, Dr. and Mrs. Carlton Lee Starkweather prepare to leave River View Cottage by horse-drawn carriage. The name of the third individual is unknown, as is the name of the black man at the far right of the frame. Below, Mrs. Sanders (or perhaps Mrs. Sandow) heads to market in a carriage pulled by oxen. Mrs. Sanders may have been the wife of John Sanders, who operated an upholstery and umbrella repair shop in the basement of what is now 208 Commerce Street.

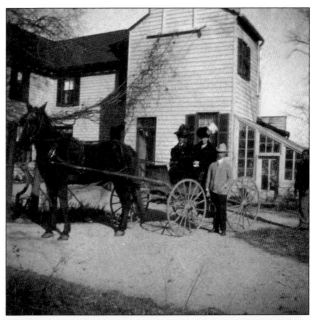

Occoquan seems to have been blessed with a number of physicians. In addition to Frank Hornbaker and Carlton Lee Starkweather, both mentioned earlier, the prominent Janney family also produced Walter H. Janney, M.D. (1874–c. 1949), who leans against a balcony railing in the photograph at left. Below, around 1925, Occoquan physician Dr. Maret works in a medical office located in the rear of the Occoquan Pharmacy. Dr. Hornbaker and his druggist friend Leamon Ledman operated the pharmacy from 1908 until Ledman moved his business out of town in 1912. Thereafter, Dr. Hornbaker continued to own the pharmacy, renting space in the rear to others.

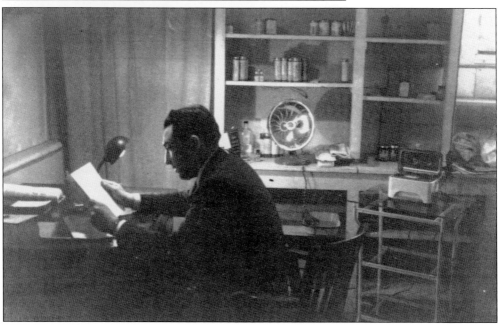

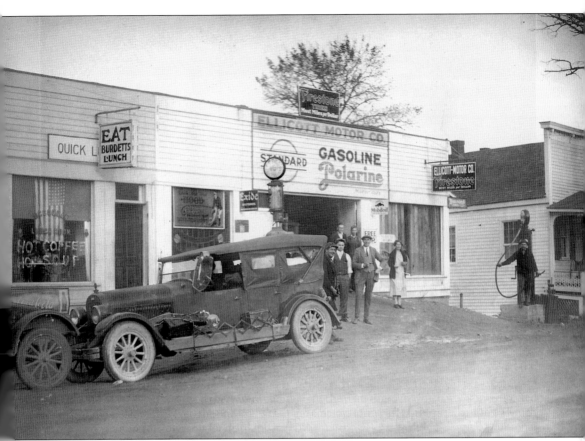

Since the days of Nathaniel Ellicott in the late 18th century, Occoquan has tried to draw the attention of travelers moving north and south along the East Coast. And for much of its history it has been successful. Even after the coming of Route 1 in the late 1920s, Route 123 continued to pass through town, descending the hills on the north bank and crossing the iron Pratt truss bridge. Accordingly, though none exist in town today, Occoquan once had its share of gasoline service stations. In the photograph above, a group loiters outside Ellicott's Motor Company and Burdett's Eatery in the early 1920s. Bob Burdett holds the hose behind the car. Next to him stands Austy Barbee, who worked at the bank, and an unidentified tourist. In the back on the left is Bob Brenner with another unidentified man. Charlie Ellicott stands on the gas pump. The woman in the photograph is Della Burdett. The W. R. Burdett family lived in the house to the right, which is now part of the Occoquan Inn.

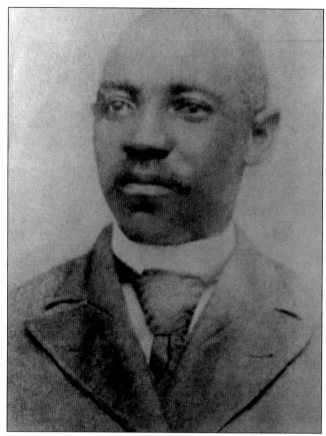

Formerly a slave, Rev. Lewis Bailey (left) gained his freedom at the age of 21 with the coming of the Civil War. In 1883, he founded Ebenezer Baptist Church in the Town of Occoquan at the corner of Washington and Commerce Streets. At the time the church's cornerstone was laid, there were more than 100 black families living in or near the town, some of them born free even during the time of slavery. Below, members of the church participate in a baptism in the Occoquan River around 1900. The congregation continued to hold baptisms in the river until the middle of the 20th century. (Left courtesy of Ebenezer Baptist Church.)

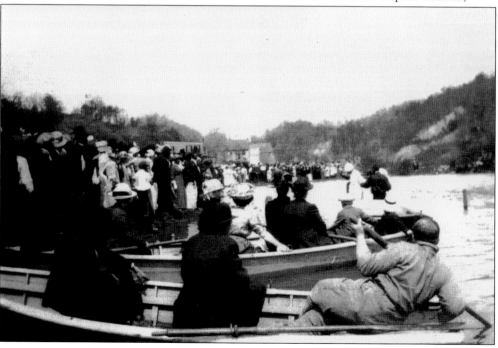

The Ebenezer Baptist Church building burned down in 1923, but the congregation quickly rebuilt on the same site. At right is the new church under construction. During this period, Washington Street between Mill and Union Streets became the center of Occoquan's black community, a position it held through the middle of the 20th century. Odd Fellows Hall was among the other prominent black establishments on Washington Street, home to an Occoquan branch of a benevolent fraternal organization that at one time was among the largest in the world. In the photograph below, members of the Odd Fellows Hall parade in regalia.

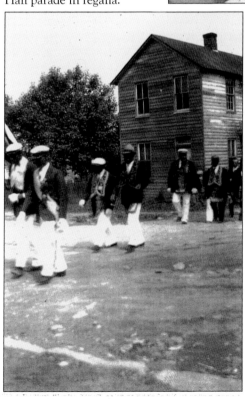

Heading south out of town on Washington Street, off to the right on a little hillock across from East Locust Street is a stone monument, pictured above, marking the former location of the Beulah Baptist Church. W. M. Smoot, who lived on Tanyard Hill Road, led this Old School or Primitive Baptist congregation while also serving as the director of the Bank of Occoquan. He allegedly insisted that upon his death no one be allowed to preach in his church, and as a result, after he died in 1938, the structure deteriorated so significantly that the local fire department burned it in a training exercise. Workers later moved the monument a few yards from its original location to accommodate the construction of a nearby subdivision. Adjacent to the monument is a small cemetery, pictured below.

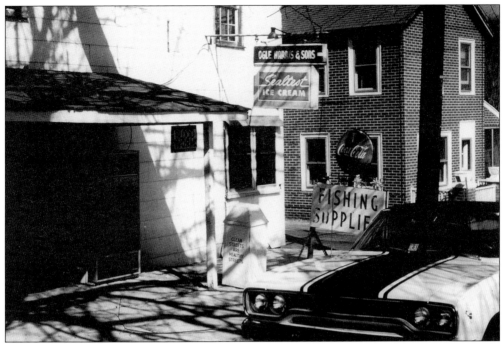

In the middle third of the 20th century, Occoquan boasted two general stores. As mentioned earlier, Ogle Harris started Ogle Harris and Sons on Washington Street in the early part of the 20th century. On Mill Street, members of the Lynn family, whose earlier store on the south side of Mill Street had burned in the 1916 fire, reopened in a new building on the north side. Above is a c. 1970 photograph of Ogle Harris and Sons store on the west side of Washington Street. Below, a photograph from 1966 shows the Lynn General Store on the north side of Mill Street; the upstairs of the Lynn building served as a residence.

Mamie Lynn Davis was one of Occoquan's prominent 20th-century residents. Upon her death she left the town an endowment for both a park and the town hall. In addition to holding other positions, she was also once the town mayor, and is remembered today in various ways. Townspeople, for example, dedicated Mamie Davis Park at the intersection of Mill and Washington Streets in her honor in 1974. The photograph at left shows Davis's house at the southern corner of Commerce and Washington Streets (the woman on the porch remains unidentified). Below is another view looking east along Commerce Street.

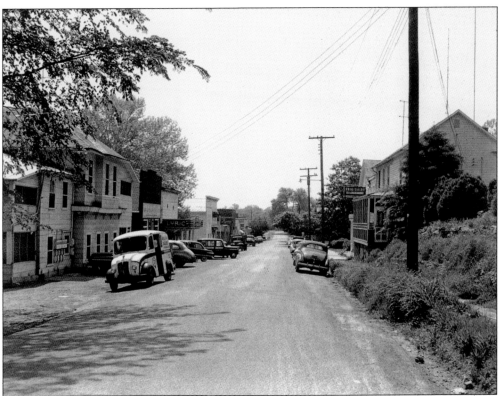

Above is a photograph from 1953 looking east down Mill Street from west of its intersection with Ellicott Street. On the left one can make out the signs for the hardware store (on the front of the building), the Lyric Theatre, and Lynn's general store. The second building on the right used to be Dr. Frank Hornbaker's pharmacy, but by this time it was part of a hardware and appliance business run by Frank Hornbaker Jr.—note the projecting sign that reads "Frigidaire." Trees obscure the remainder of Mill Street on the right, but far down the block at one time was the Bank of Occoquan, relocated from its earlier site on Union Street after the fire of 1916. At right is one of the bank's deposit slips from the 1940s.

DEPOSITED IN

BANK OF OCCOQUAN, Inc.

OF OCCOQUAN, VA.

By

194

PLEASE LIST EACH CHECK SEPARATELY

The right is reserved, and the Bank is authorized to forward items for collection or payment direct to the drawee or payor bank, or through any other bank, at its discretion, and to receive payment in drafts drawn by the drawee or other banks, and, except for negligence, this Bank shall not be liable for dishonor of the drafts so received in payment, nor for losses thereon.

CURRENCY

SILVER

CHECKS AS FOLLOWS:

TOTAL $

SEE THAT ALL CHECKS AND DRAFTS ARE ENDORSED

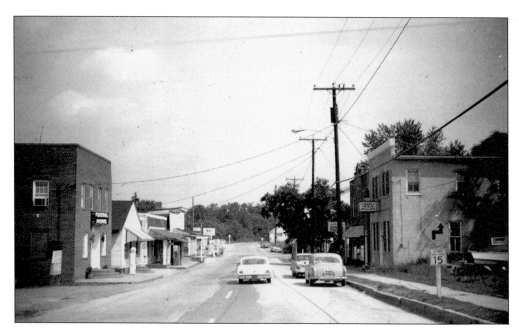

The photograph above dates from 1966 and once again looks east down Mill Street, this time from east of Mill's intersection with Ellicott. Here the bank on Mill Street, by this time known as the Bank of Prince William, is visible on the right, while just beyond it is the Jennings Drugs store. The first building on the left of the photograph is Hall's Funeral Home. Below is another view of the funeral home, now from the south side of Mill Street.

Herman F. Jennings and Myrtle Blocker, pictured at right, married each other on June 8, 1933. In March 1945, they purchased the building at 306 Mill Street and opened Jennings Drugs, where the Alton Hotel had once welcomed travelers to Occoquan. Taken two months later, in May 1945, and sent to Myrtle's mother, Daisy Mae Blocker, the photograph below shows Myrtle, Estelle Garrison (who worked in the store), and Herman and Myrtle's four-year-old son William Jennings, in front of the Jennings' new business. A bicycle lies on the sidewalk in front of the store. (Courtesy William Jennings.)

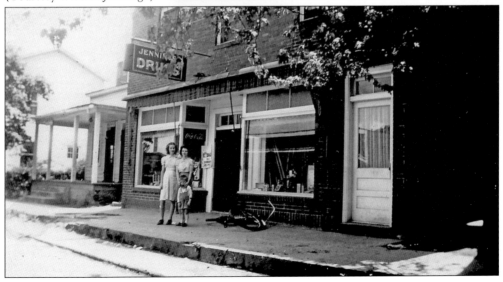

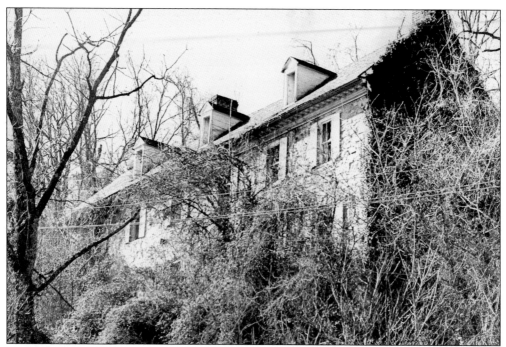

Laurence Barnes and his wife left Rockledge Mansion in 1960, complaining that work at the quarry across the river had damaged the house so severely that it could no longer be safely occupied. By the late 1960s, vandals had stripped away parts of the interior, and broken windows left the structure open to the elements. Eventually Donald Sonner purchased Occoquan's oldest landmark and worked to restore it to former glory. Unfortunately, his efforts were not fully rewarded; in January 1980 an arsonist set fire to the mansion, causing $250,000 in damages. The fire-scarred Rockledge again became a target for vandals.

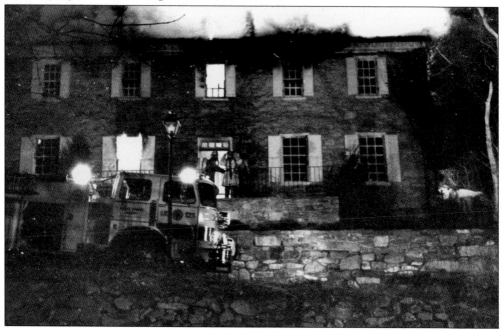

Five

HURRICANE AGNES

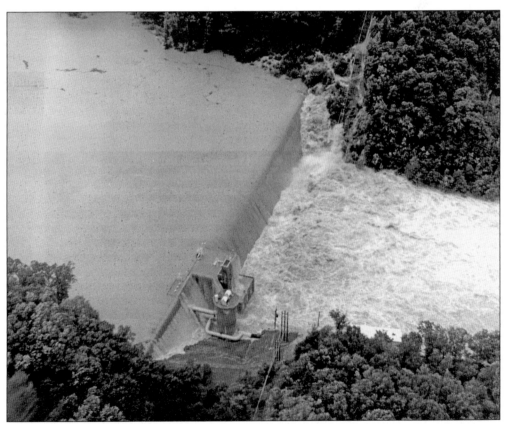

Agnes was the first hurricane and tropical storm of 1972, and a seminal event in Occoquan's history. After first striking the Florida Panhandle, it moved northeast to devastate the mid-Atlantic coast, including the Town of Occoquan. At 3:00 p.m. on June 22, 1972, floodwaters caused by Hurricane Agnes poured over the Occoquan High Dam.

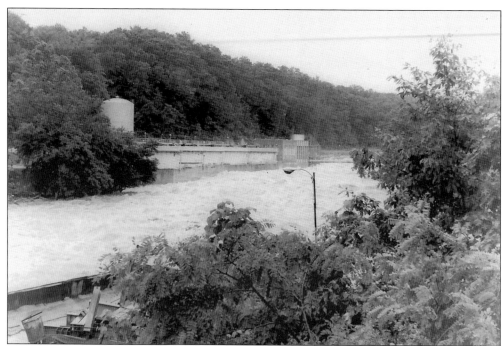

In the photographs above and below, the Occoquan River, swollen well beyond its normal boundaries, rages past what was then the Fairfax Water Authority's main treatment facility on the south bank of the river, just northwest of town. Hurricane Agnes was the worst disaster the Water Authority had ever experienced. Storm water flooded the treatment facility, damaged the transmission line from the reservoir, and caused depletion of the water storage tanks and a loss of system pressure. The treatment plant shut down all operations for 35 hours, and it took extensive efforts by federal and local authorities to restore full service some eight days later.

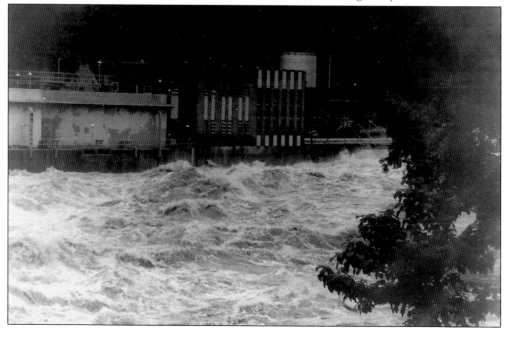

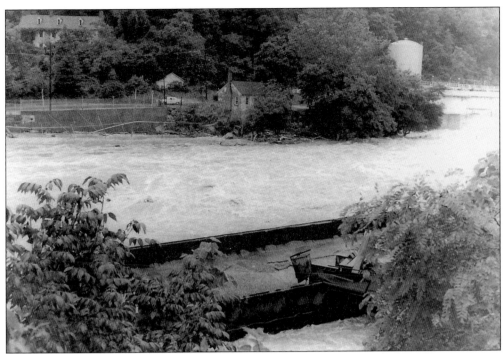

As the surging floodwaters of the Occoquan River proceed along their path to the Potomac, they pass just below the old Mill House in the photographs above and below. On the south bank of the river at the far northwestern end of town, the overwhelming current swept away most of any ruins that remained of the 18th-century Merchants' Mill and Country Mill. In the photograph above, one can see the water treatment plant on the right, a quarry barge in the foreground, and Rockledge mansion on the left. Note the battered and tangled fencing below the concrete wall to the left of the Mill House.

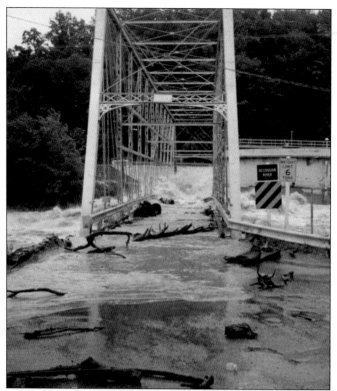

Prior to Hurricane Agnes, the Virginia Department of Highways stirred the ire of Occoquan residents by proposing replacement of the 1878 iron Pratt truss bridge with a new, more modern structure at the other end of town. Despite the state's safety concerns, some residents expressed sentimental attachment to the old structure, others feared that a new low bridge would divide the town and hurt business by diverting traffic from Mill Street. Still others argued that the bridge provided important shade during the herring spring spawning season. Little did anyone know at the time that nature would make the final decision—in the photographs at left and below she begins to do so.

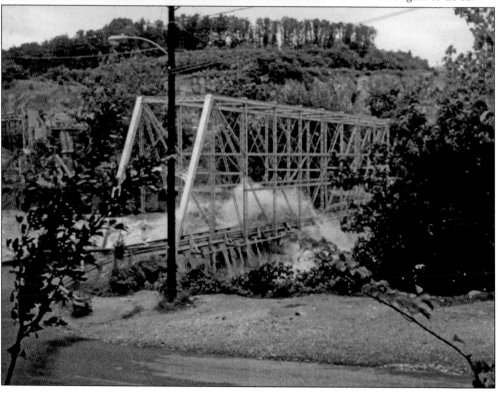

In the following four sequential photographs taken from the Fairfax County (or north) shore of the river, Hurricane Agnes and the flood-choked waters of the Occoquan River destroy the iron Pratt truss bridge that had stood for nearly a century.

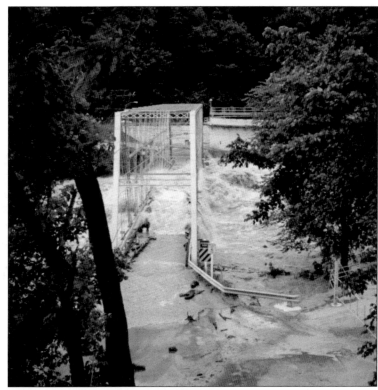

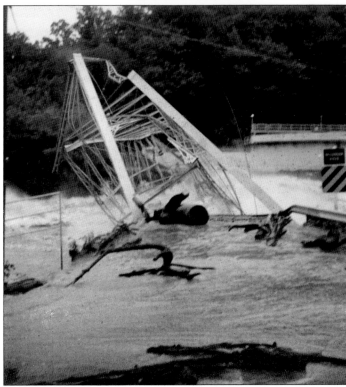

Floodwaters destroyed Nathaniel Ellicott's first bridge over the Occoquan River in 1807, requiring the construction of a replacement.

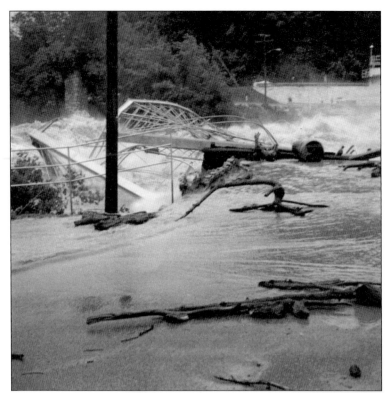

Sometime before the Civil War, that bridge too was destroyed, and in 1878, engineers and workmen erected a new, modern iron Pratt truss bridge.

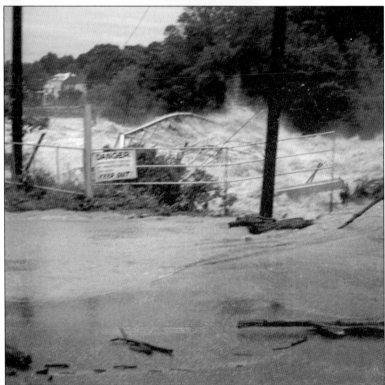

On June 22, 1972, that bridge met its end as well.

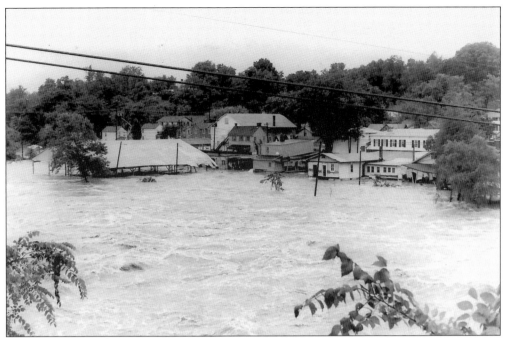

Hurricane Agnes dumped more than 16 inches of water over 36 hours in the Occoquan area. The volume and pressure was simply too much for the river's banks as the water rushed down from the Piedmont and over the top of the Occoquan High Dam. Low-lying property on the eastern end of town flooded, sometimes up to the second story in the rear of the buildings. In the photograph above, the waters reach almost to the bottom of a protective roof that covers the boat slips at the Prince William Marina. Below, the waters carry boats over land and deposit them on Mill Street.

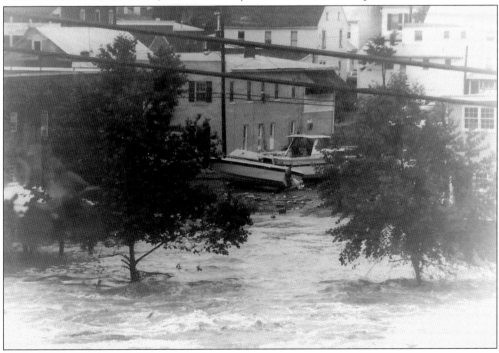

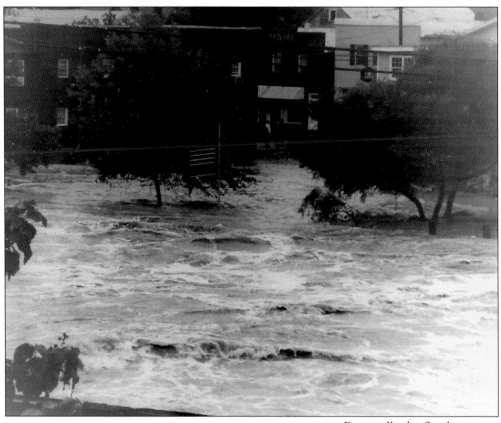

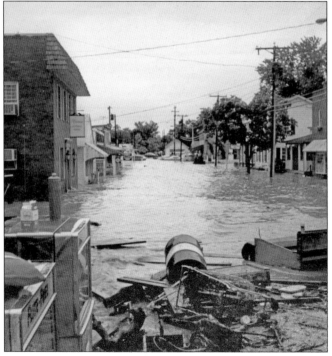

Eventually the floodwaters completely inundated parts of Mill Street. The above photograph shows the waters pressing in upon Occoquan's main thoroughfare. At left is a photograph looking to the east down Mill Street. On the left is the funeral home with water lapping at its elevated front threshold; at right center, water threatens the Blackbeard Inn. Down the street on the right a van and a car face submersion in front of the volunteer firehouse, while on the left a loosened boat floats backwards into Mill Street. Note the life preserver sitting atop the gasoline pump near what would have been Lynn's General Store.

Today the worst-case scenario for an Occoquan High Dam failure predicts that water would reach Commerce Street within 20 minutes of the event. The floodwaters of Hurricane Agnes did not assume such dimensions, but they did start up the avenues running south from Mill Street. At right is a photograph looking down Union Street toward the river. Tyson Janney's old residence on Mill Street, then and now the Occoquan Inn, sees water approach the sills of its high first floor windows. A boat wanders near the Blackbeard Inn on the left. The image below provides a look to the south, up Union Street, showing some of the street damage caused by the flooding.

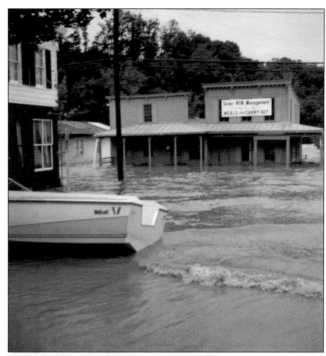

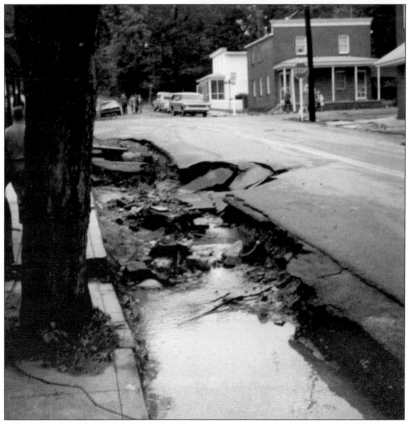

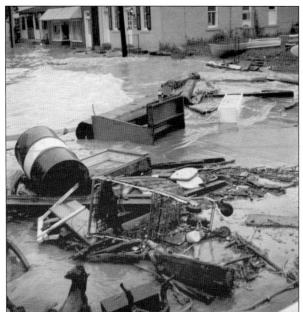

Until 1979, Hurricane Agnes remained the worst hurricane on record. Estimates placed the total damage caused along its path in excess of $1.5 billion. Although no fatalities occurred in Occoquan, most of the town's businesses were damaged. Understandably hardest hit were those in the lowest-lying areas along the waterfront between Washington and Ellicott Streets. At left is a photograph showing some of the flotsam that gathered toward the Ellicott Street end of Mill Street. The bank and Jennings Drugs are visible in the background. Below, at the southeastern end of Mill Street near its intersection with Washington Street, floodwaters inundate Prince William Marina.

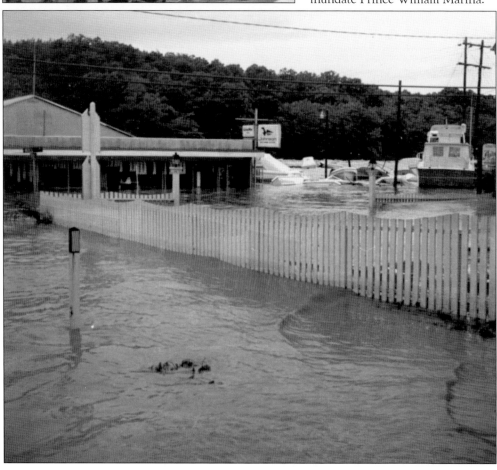

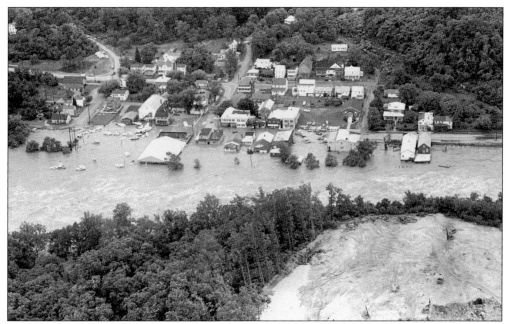

Two aerial photographs of Occoquan show the extent of the flooding caused by Hurricane Agnes. In the photograph above, the quarry on the north side of the river sits in the lower right corner. Floodwaters cover Mill Street from its intersection with Washington Street on the far left to approximately halfway between Ellicott Street and the Mill House, which is off the photograph's border to the right. Below is a closer shot of the southeastern end of Mill Street, revealing greater detail. Boats from Prince William Marina rest against the fire station and the post office, and float up Union Street. Though unclear here, residents from the time reported that caskets from the funeral home joined the floating debris.

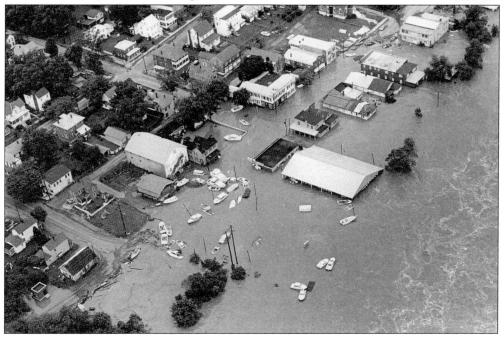

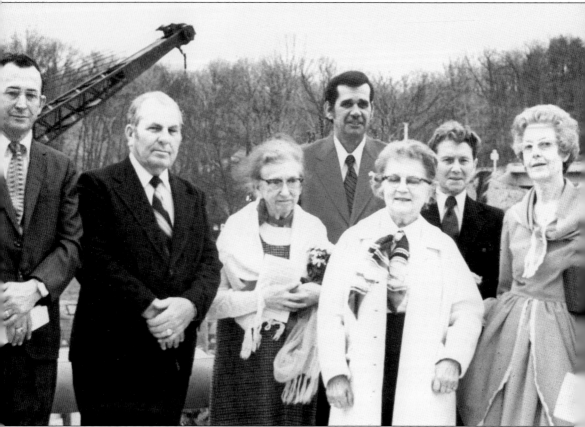

Hurricane Agnes devastated Occoquan, but the aftermath was arguably more difficult than the storm itself. Some businesses that suffered damage shuttered forever. Others attempted unsuccessfully to rebuild and reopen. For the community as a whole, crucial decisions remained about the future direction of the town. Within two years an anniversary beckoned. Though chartered at the initiative of Nathaniel Ellicott in 1804, Occoquan became an incorporated town under Virginia law in 1874. The photograph above shows the town clerk and members of the Occoquan Town Council who were in office the year of that 100th anniversary, and who were thus in many ways responsible for putting the town back on a path to prosperity. They are, from left to right, councilman Charles E. Pugh, mayor Herbert L. Mooney, town clerk Mamie L. Davis, councilman Donald C. Lynn, councilwoman Myrtle B. Jennings, councilman Russell Nelson, and councilwoman Louise P. Lincoln.

Six

OCCOQUAN AT ITS THIRD CENTURY

Though Hurricane Agnes dealt Occoquan a hard blow, the town had weathered challenges in the past. As after the fire of 1916, those who remained, rebuilt. When the town's third century dawned, the people of Occoquan looked forward to a prosperous future. Above, in an annual charitable tradition, the Occoquan Town Hall tree becomes the "Tree of Hope" during the Christmas holiday.

Despite the passage of a half-century, the view of Mill Street from the northwest was still familiar to many as Occoquan entered the new millennium. In the photograph above, the first white building on the left is what remains of the Lyric Theatre; the next white building is the former site of Lynn's General Store.

This photograph from 2001 shows 404 and 406 Mill Street. The building on the left once housed the Occoquan Pharmacy (see page 75) opened in 1908 by Dr. Frank Hornbaker. Both the second floor and the rear of the building host a restaurant in what was the home of Dr. Hornbaker's widow, Grace Lynn Clarke. A portrait of her hangs there to this day.

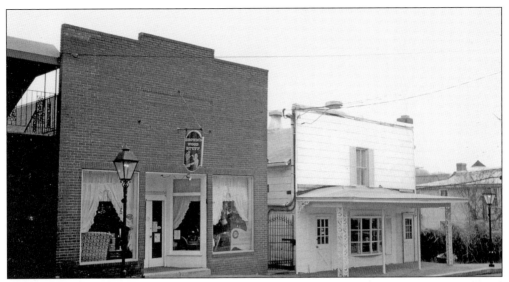

The Lyric Theatre (see page 76) closed during the 1950s and little but the facade of the original structure remains. In the 2001 photograph above, the old Lyric Theatre building is on the right, now part of an antique store. To the left is a portion of the former warehouse and general store complex founded by Tyson Janney.

The Occoquan Hotel (see page 64) is no more, destroyed by fire in 1916. In its place at 402 Mill Street, shown above, stands one of the most beautiful buildings in Occoquan. Not visible in the photograph, an old carriage stone sits outside of the current structure, abutting the curb on the south side of Mill Street. Visit and judge for yourself if it is the same stone that once sat outside the Occoquan Hotel.

The fire of 1916 destroyed both John Underwood's home on Mill Street (see page 65) and the First Methodist Church on Commerce Street (see page 60). In 1926, locals constructed another Methodist church on the Underwood lot at 314 Mill Street. Many years later, in 1963, the Town of Occoquan purchased the church building and today it serves as the Occoquan Town Hall, shown above.

Not fire, but instead Hurricane Agnes, forced the closure of the funeral home at 309 Mill Street (see page 90). But as the photograph above from 2001 shows, the building remains. Since 1977, the remodeled-but-still-easily-recognizable structure has housed one of Occoquan's best-known art studio cooperatives.

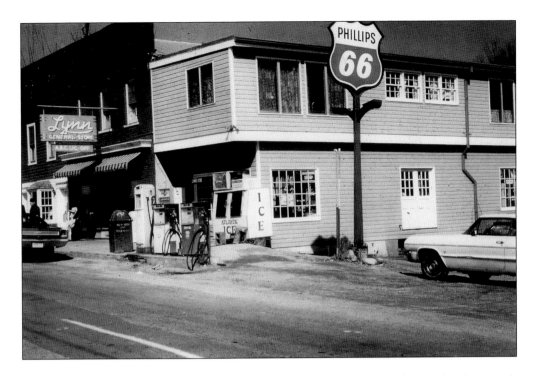

The Lynn General Store and the pumps for Phillips 66 gasoline, both shown in the photograph above, once stood across from the former Underwood House, Methodist church, and now the Occoquan Town Hall. Though the general store no longer exists, the Lynn family has ensured passersby remember the heritage of the building at 313 Mill Street. Home now to several retail establishments, including another one of Occoquan's art cooperatives, the sign shown in the photograph below reads "Lynn's River Center–Established 1917." Lynn family members continue to own numerous properties in town, both along the waterfront and to the south of it.

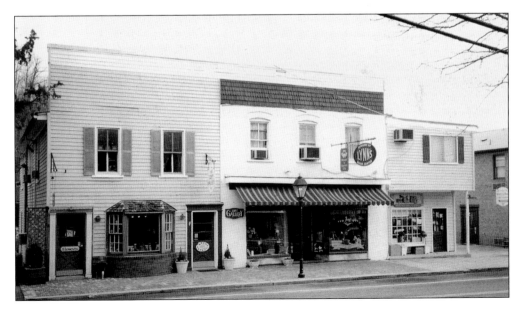

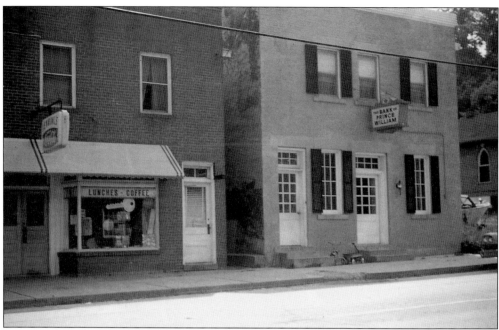

As it did with so many other structures in town, the 1916 fire put an end to the Alton Hotel (see page 63), only to see it later succeeded by a bank and Jennings Drugs store, both shown in the photograph above on the right and the left, respectively. Although the latter two businesses closed after the floodwaters of Hurricane Agnes swept through town, the buildings themselves remained. The photograph below shows the former home of Jennings Drugs at 306 Mill Street occupied today by a local jewelry store. A decorative craft business resides in the former bank building at 308 Mill Street.

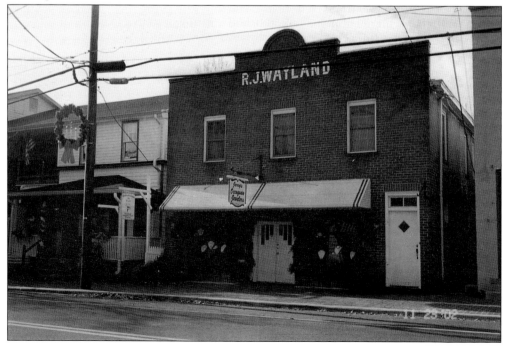

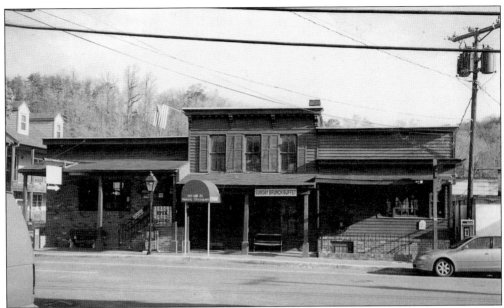

A building still stands at 301–303 Mill Street where Tyson Janney once lived in the early 20th century (see page 66). Here he came with his new bride Helen Meta Gibson, after moving out of the Janney family residence at Rockledge. The structure and its occupants have weathered a variety of misfortunes over the years since the Janneys departed. In addition to tough economic times, the violent floodwaters of Hurricane Agnes crashed into the rear of the building and rose to the level of the windows on the Mill Street frontage. Today the building houses two restaurants and a basement bar.

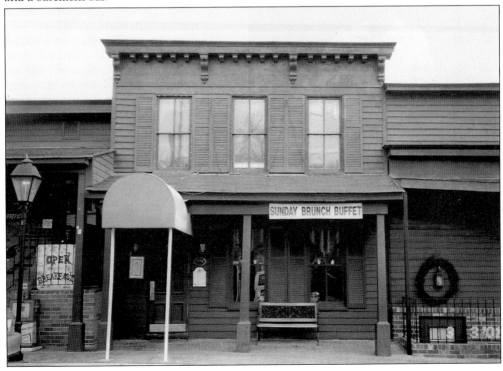

The building at 302 Mill Street once housed the Blackbeard Inn, shown above, and dates from approximately the middle of the 19th century. In 1972, floodwaters from Hurricane Agnes forced dislodged boats against the building. The former owner of the inn, Don Sooner, at one time purchased the abandoned and vandalized Rockledge mansion and worked hard to restore it to a suitable condition. To everyone's misfortune, his work was undone by an arsonist in 1980 (see page 92). Today the building at 302 Mill Street is home to one of Occoquan's most popular retail destinations, shown in the photograph below.

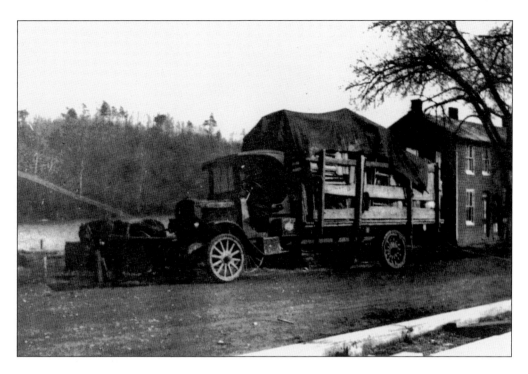

The photograph above purports to show Occoquan's old post office behind the truck in the center of the picture. Today the Occoquan Post Office sits at 202 Mill Street, below. No postman delivers mail to town residents and businesses; instead, everyone with a town zip code goes to 202 Mill Street to collect their letters, packages, and periodicals. This has made the Occoquan branch of the postal service a particularly integral part of the community. Occoquan's list of postmasters goes back to the early 19th century, and includes numerous well-known Occoquan names—Ellicott, Janney, Lynn, Selecman, and Hammill to name but a few.

The Occoquan-Woodbridge-Lorton Volunteer Fire Department continues to protect the town of Occoquan, but in 1958 it moved out of town to a new facility. Where the station in the town once stood, men and women who have served their community in another way are honored. Above, a photograph shows the former fire station at 204 Mill Street (see page 70); it is now the home of Occoquan's Veterans of Foreign Wars Post 7916.

South of Mill Street, Occoquan's other main east-west thoroughfare, Commerce Street, also retains some markers of its past. The First Methodist Church building no longer exists, destroyed by the fire of 1916 (see page 60). After the start of the 21st century, however, there were still recognizable landmarks. Among the most notable of these is the house on the right in the photograph above.

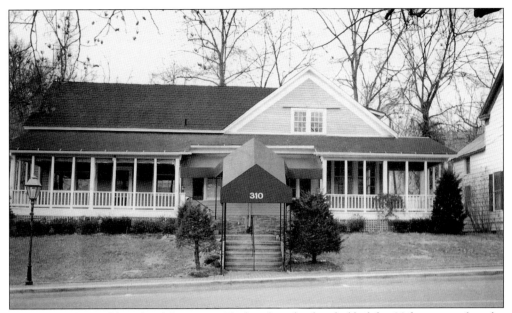

Occoquan's first public school (see page 61) closed in the first half of the 20th century, but the building it once occupied remains in use today. As the photograph above shows, renovations have changed its look. No longer, for example, does a bell tower top its roof, nor do wooden fence posts guard its Commerce Street frontage.

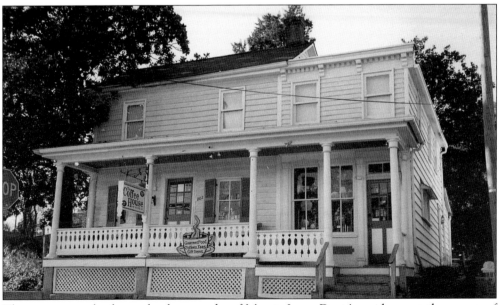

There appear to be few early photographs of Mamie Lynn Davis's residence at the corner of Commerce and Washington Streets (see page 88). Nevertheless, the structure is still recognizable today as a popular coffee house and one of the first buildings many people notice upon entering the town.

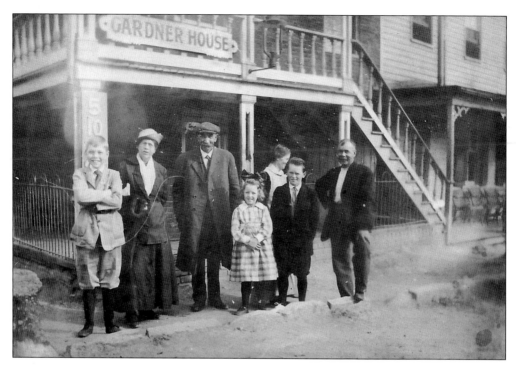

At the corner of Commerce and Union Streets, the old brick building that was once the Hammill Hotel, and later the Gardner House, continues to stand. In the photograph above, an unidentified group of men, women, and children pose in front of the Gardner House porch. Although its dimensions are recognizable even today, the current building, pictured below, no longer boasts a porch or balconies. A local historical marker that the town erected adjacent to the building on Commerce Street continues to draw the attention of tourists, and retail and service businesses make regular use of the first floor.

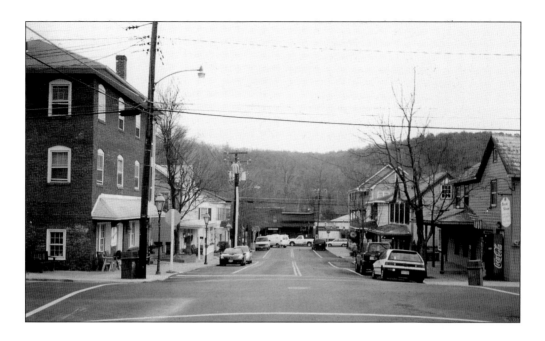

Union Street also bears some resemblance to much earlier days (see page 58). Occoquan's bank, destroyed by the fire of 1916, was rebuilt and moved to Mill Street, but the Hammill Hotel/Gardner House building remained. Above, in a photograph from 2001, looking down Union Street toward Mill Street, the Hammill Hotel/Gardner House can be seen on the left, while at the far end, the former site of Tyson Janney's residence at the intersection of Union and Mill Streets is clearly visible. The photograph below looks up Union Street toward Commerce Street. Again, the old Hammill Hotel/Gardner House may be seen at the corner by the stop sign. Two centuries ago, Occoquan's tanning yard would have been off to the left beyond the stop sign.

The vistas along both Commerce and Washington Streets have changed dramatically over the years, but some landmarks remain. In the photograph above, looking west on Commerce Street, the former house of Mamie Lynn Davis sits on the left, and the Hammill Hotel/Gardner House is once again visible in the center-right background. Far in the upper left corner one can glimpse some of the townhouses that now reside on the hills above Rockledge. Below, the vista down Washington Street toward Mill Street is substantively devoid of old landmarks, save for the awning on the left, which marks the former site of Ogle Harris and Sons store; Ebenezer Baptist Church is out of the frame to the right. A gazebo in the distance shows the location of Mamie Davis Park.

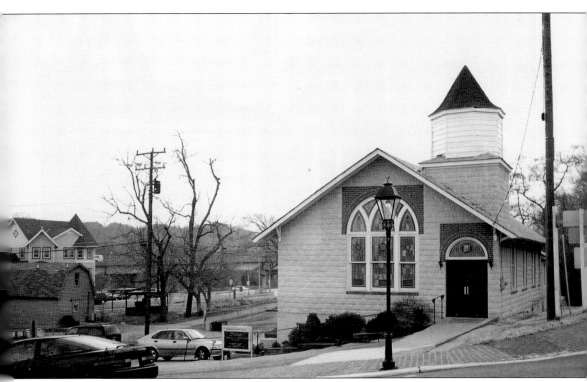

The fire that burned down their first structure in 1923 could not crush the spirit of Rev. Lewis Bailey's congregation at the Ebenezer Baptist Church. They quickly rebuilt and today Ebenezer is the only active church in the Town of Occoquan. Although the congregation now holds most of its services at a much larger facility constructed in 2000 at the intersection of Minnieville and Telegraph Roads, Ebenezer nevertheless remains an integral part of the Occoquan community. Among the special annual church services especially prized by town residents is the town blessing, held during the Christmas season at the historic church site, and the Easter sunrise service held in Mamie Davis Park. In the photograph above from 2000, the current historic church site dominates the frame while to the left is the back of the County Tourist Information Center.

Like many other Occoquan businesses, the Ogle Harris and Sons store suffered as a result of Hurricane Agnes, struggling to survive during the subsequently difficult economic times. Although it remained open for a limited time during the summer months, conditions soon forced its closure. Today a town history marker commemorates what was once a cornerstone of Occoquan's African-American commercial community. A craft and sewing business, shown here, now occupies the building at 204 Washington Street. Visitors to the current structure, however, once inside, may still easily conjure up an image of Ogle Harris and his son Arthur standing behind a large container of Nehi (see page 69). Several members of the Harris family still reside in Occoquan. Ogle Harris's daughter, Miss Artie Lee Harris, once Occoquan's oldest living resident, passed away on December 24, 2009, at the age of 107.

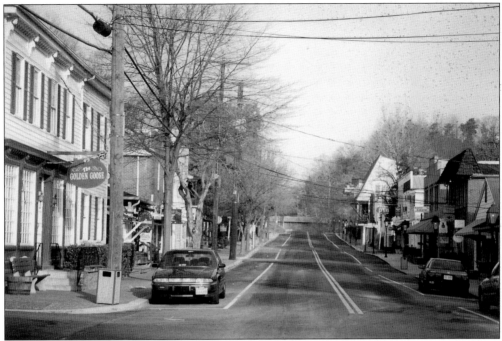

Few old photographs look west down Mill Street to offer a comparison with the present day. In the 2001 photograph above, the building that formerly housed the Blackbeard Inn is on the left. On the right is the former funeral home building, the former site of Lynn's General Store, and the canopy on the old Lyric Theatre building. Where the old Janney warehouse once stood there is an old boat storage facility. At the far end, the wall-like structure is the side of a water storage tank. Below, another photograph from 2001 provides an elevated view of Mill Street looking to the west.

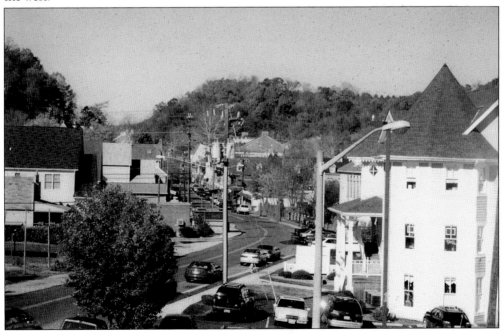

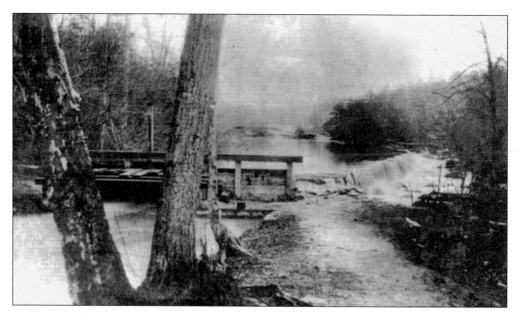

At one time, a small dam slowed the current of the Occoquan River, redirecting some of its flow into a man-made race that carried the water downstream, where it could be used to power the town's mills. A 20th-century dam put an end to the millrace, but the new dam also harnessed the energy of the river. For a time it generated electrical power, but more importantly, it has provided drinking water not only to the Town of Occoquan, but to more than a million people throughout northern Virginia. In the above photograph, a small footbridge crosses the old millrace where it connected to the Occoquan River. Below, an aerial photograph shows the Occoquan High Dam and the reservoir it created.

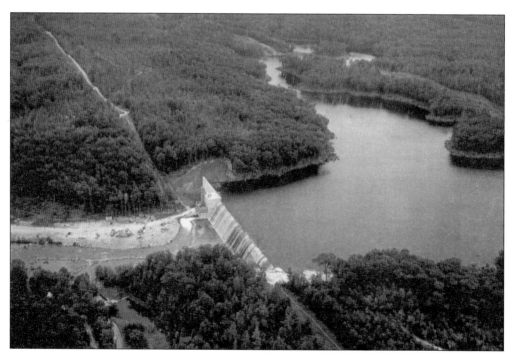

When Hurricane Agnes destroyed the 1878 iron Pratt truss bridge, the Commonwealth of Virginia constructed a new bridge at the eastern end of town. The photograph above shows the new bridge from the southeast shortly after construction. Below, a later photograph shows the bridge from the town wharf after additional renovations in the early 21st century. Grant money helped fund construction of the public wharf in the foreground. That wharf extends over the old 19th-century dike that once protected ships from floating ice, lumber, and other river debris (see page 25). Off to the right under the bridge and above the docked boats are trees that also grow on the remains of the old dike.

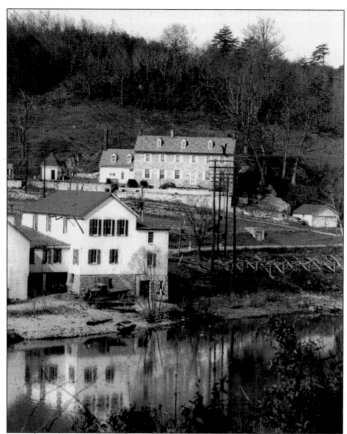

In the early 1970s, a publication prophesied that Rockledge mansion was beyond the point of no return, with no hope of restoration. By the 1980s, vandalism, neglect, and arson no doubt led many to concur. Yet Rockledge mansion has survived. A succession of owners and occupants has strived to maintain the structure. It is now home to several businesses and a frequent site of weddings, receptions, funeral services, and various other social and business gatherings. The early 20th-century photograph at left shows Rockledge and the Janney warehouse. The photograph from the early 21st century below shows Rockledge preparing for the winter holidays.

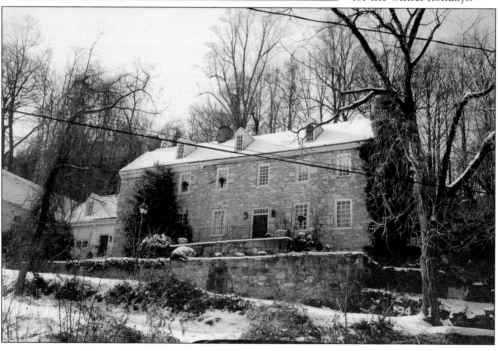

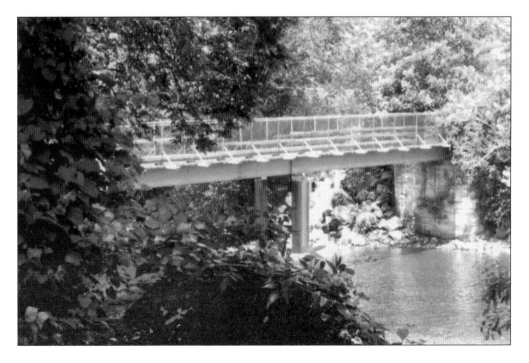

OCCOQUAN 47
EXP. 4-15-70

Occoquan is committed to remembering its heritage, and members of the community continue to uncover items from the town's past. Above is an Occoquan license plate from 1970 donated to the town by Lowell Sawyer. Others outside of town have helped as well. Although after Hurricane Agnes the Virginia Department of Highways insisted on reconstructing an Occoquan River bridge at the eastern end of town, they were not unsympathetic to the pleas of Occoquan residents. For the enjoyment of residents and visitors they built a footbridge, pictured below, at the location of the old iron Pratt truss bridge. In 2007, as part of the yearlong statewide commemoration of the 400th anniversary of Jamestown's founding, the Town of Occoquan dedicated the bridge to town founder Nathaniel Ellicott.

Damaged by fire in 1924, the Mill House sat neglected for more than 20 years. Its walls remained intact, but its roof eventually collapsed. Then the local water authority took control of the structure, restoring it for use as office space. Approximately 20 years later, Fairfax Water made the building available to Historic Occoquan, Inc. (now the Occoquan Historical Society). Today the Occoquan Historical Society operates the Mill House Museum out of the structure. Founded in 1969, the Historical Society is dedicated to preserving Occoquan's history for future generations. This book has been published in part to honor those individuals who had the foresight to take on that challenge. The members of Historic Occoquan's original 1969 board of directors were Martha Lynn, June Randolph, Jesse R. Curtis, Stanley R. Herndon, James E. Timberlake Jr., Charles L. Deane, C. Lacey Compton Jr., Margaret F. Gets, Joan Rainwater, and Edison M. Lynn Jr.

BIBLIOGRAPHY

Brown, George. *A History of Prince William County*. Edited by Lucy Phinney. Prince William, VA: Historic Prince William, Inc. 1994.

Davis, John. *Travels of Four Years and a Half in the United States of America During 1798, 1799, 1800, 1801, and 1802*. New York: Henry Holt and Company, 1909.

Harrison, Fairfax. *Landmarks of Old Prince William: A Study of Origins in Northern Virginia*. 1924. 2nd reprint edition. Baltimore, MD: Gateway Press, 1987.

Kamoie, Laura Croghan. *Irons in the Fire: The Business History of the Tayloe Family and Virginia's Gentry, 1700–1860*. Charlottesville, VA: University of Virginia Press, 2007.

Kamoie, Laura Croghan. *Neabsco and Occoquan: The Tayloe Family Iron Plantations, 1730–1830*. Prince William, VA: Prince William Historical Commission, 2003.

Matthews, Linda Hammill. "The Hammill Hotel or the Alton Hotel? Mistaken Identities in Occoquan." *Prince William Reliquary* 8, no. 2 (April 2009): 27–30.

Morton, Richard L. *Colonial Virginia*. Vol. 1, *The Tidewater Period, 1607–1710*. Chapel Hill, NC: The University of North Carolina Press, 1960.

Occoquan-Woodbridge-Lorton Volunteer Fire Department. *50th Anniversary Photo Album*. Virginia: OWL VFD, 1988.

Phinney, Lucy Walsh. *Yesterday's Schools: Public Elementary Education in Prince William County, Virginia, 1869–1969*. Virginia: Lucy Walsh Phinney, 1993.

Prince William: The Story of Its People and Its Places. Manassas, VA: The Bethlehem Club, 1988.

Skaggs, David Curtis. "John Semple and the Development of the Potomac Valley, 1750–1773," *The Virginia Magazine of History and Biography* 92, no. 3 (July 1984): 282–308.

Tilp, Frederick. *This was Potomac River*. Alexandria, VA: Frederick Tilp, 1978.

Walsh, Lorena S. "Land Use, Settlement Patterns, and the Impact of European Agriculture, 1620–1820." In *Discovering the Chesapeake: The History of an Ecosystem*, edited by Philip Curtin, Grace S. Brush, and George W. Fisher, 221–248. Baltimore, MD: The Johns Hopkins University Press, 2001.

www.arcadiapublishing.com

Discover books about the town where you grew up, the cities where your friends and families live, the town where your parents met, or even that retirement spot you've been dreaming about. Our Web site provides history lovers with exclusive deals, advanced notification about new titles, e-mail alerts of author events, and much more.

MADE IN THE USA

Arcadia Publishing, the leading local history publisher in the United States, is committed to making history accessible and meaningful through publishing books that celebrate and preserve the heritage of America's people and places. Consistent with our mission to preserve history on a local level, this book was printed in South Carolina on American-made paper and manufactured entirely in the United States.

This book carries the accredited Forest Stewardship Council (FSC) label and is printed on 100 percent FSC-certified paper. Products carrying the FSC label are independently certified to assure consumers that they come from forests that are managed to meet the social, economic, and ecological needs of present and future generations.

FSC
Mixed Sources
Product group from well-managed forests and other controlled sources

Cert no. SW-COC-001530
www.fsc.org
© 1996 Forest Stewardship Council

Find Your Place in History.